LAMORA JAY

BBW

BEAUTIFUL BLACK WOMEN COLORING BOOK

LAMORA JAY LLC.

To our valued customers

Thank you for choosing our coloring book! We appreciate your support, it helps us stay motivated and wanting to create more books. We can't wait to see what you have created.
Please send us your finished work and you may be seen on our page.

Instagram: Lamorajayllc

THIS BOOK BELONGS TO

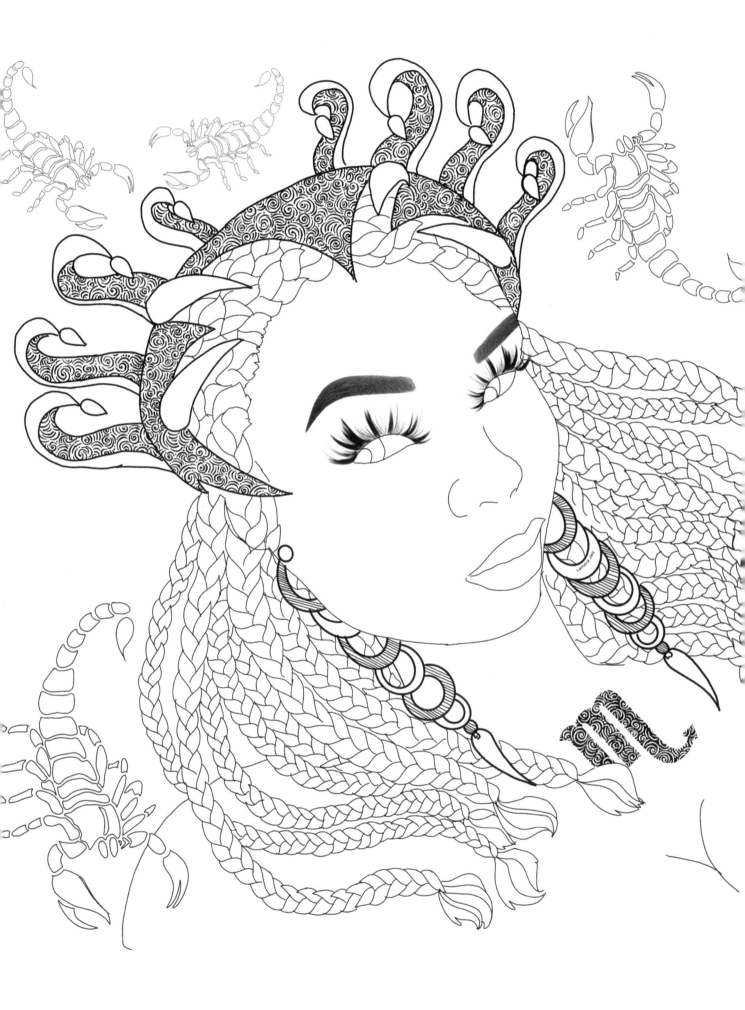

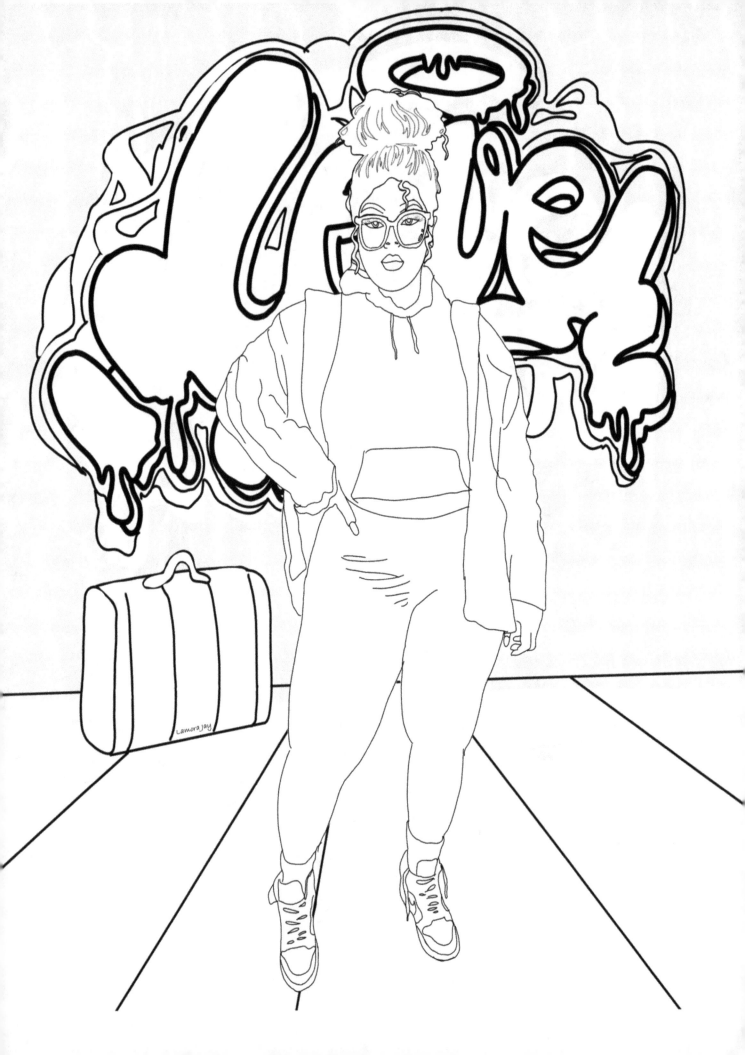

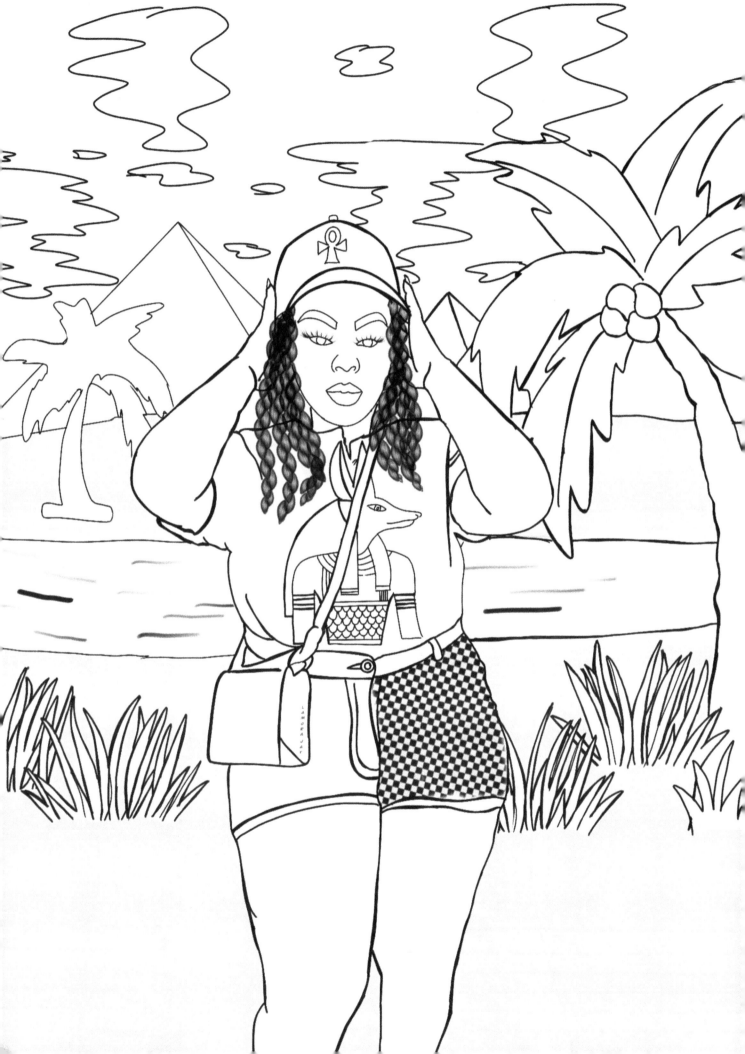

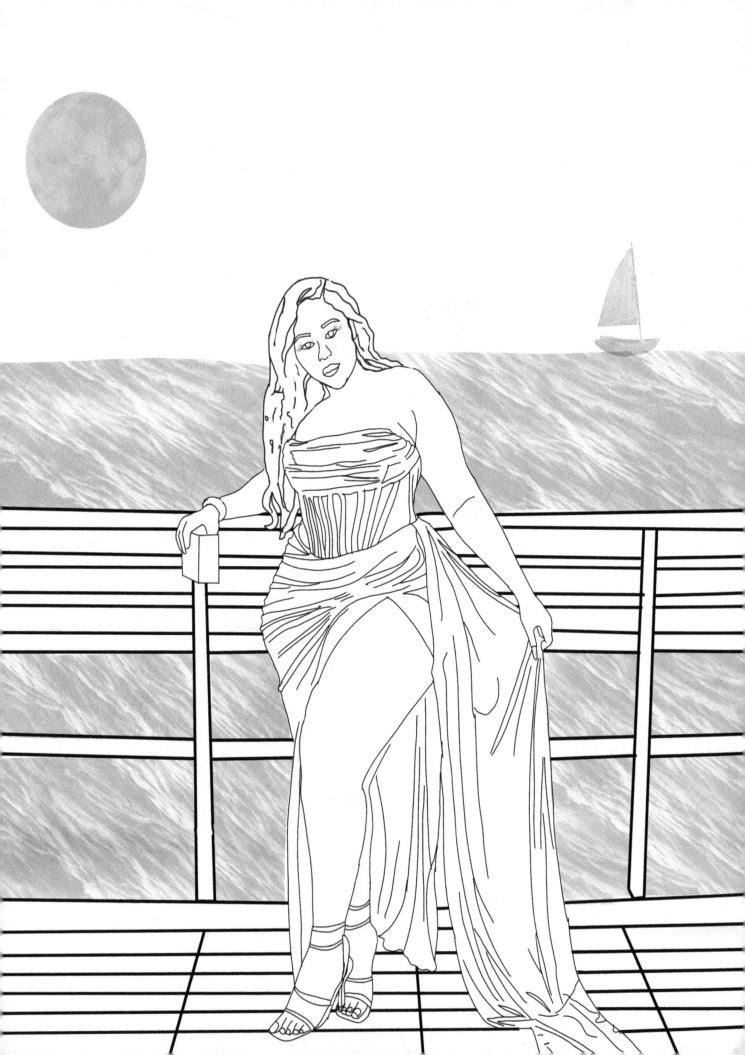

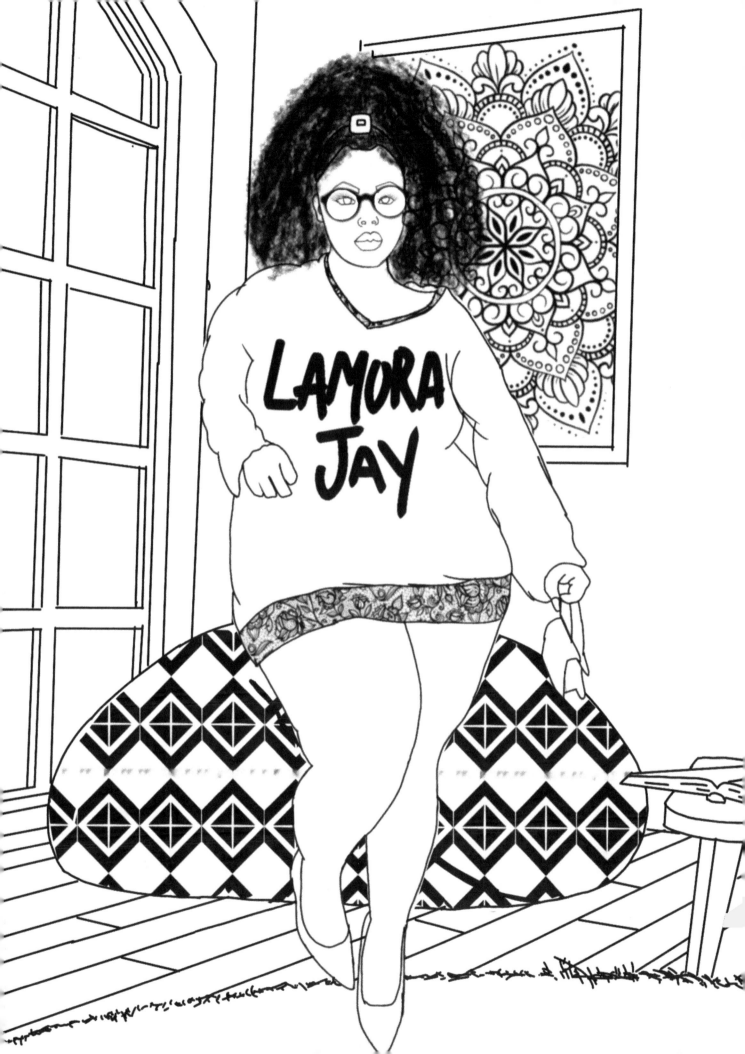

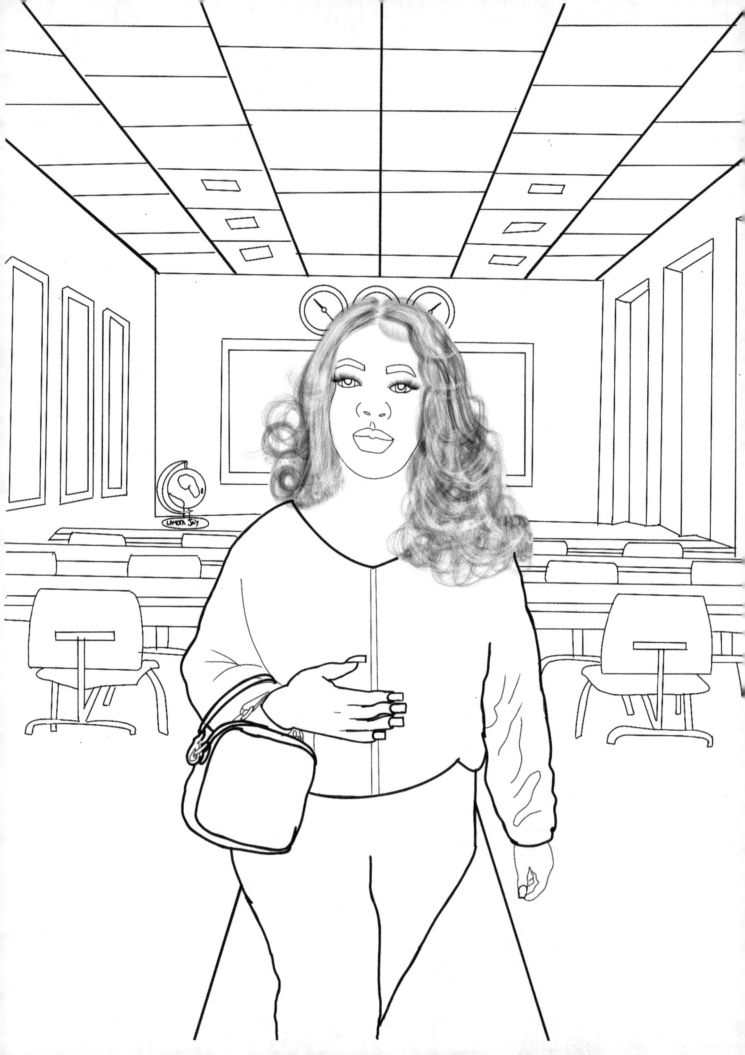

BLACK DON'T CRACK

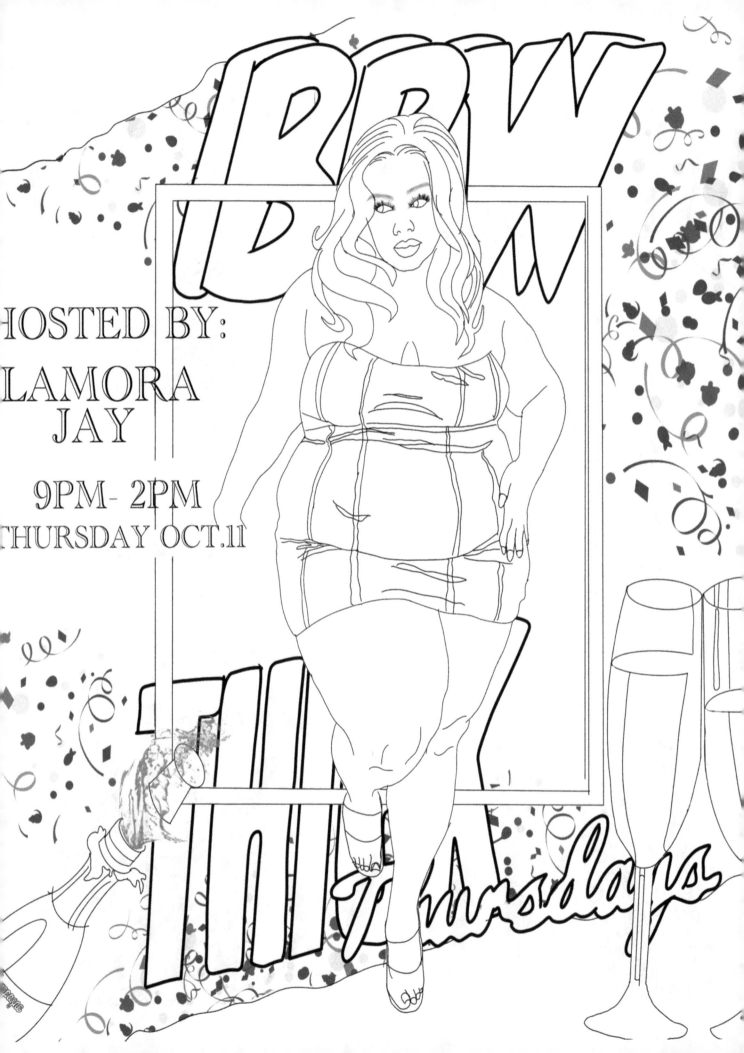

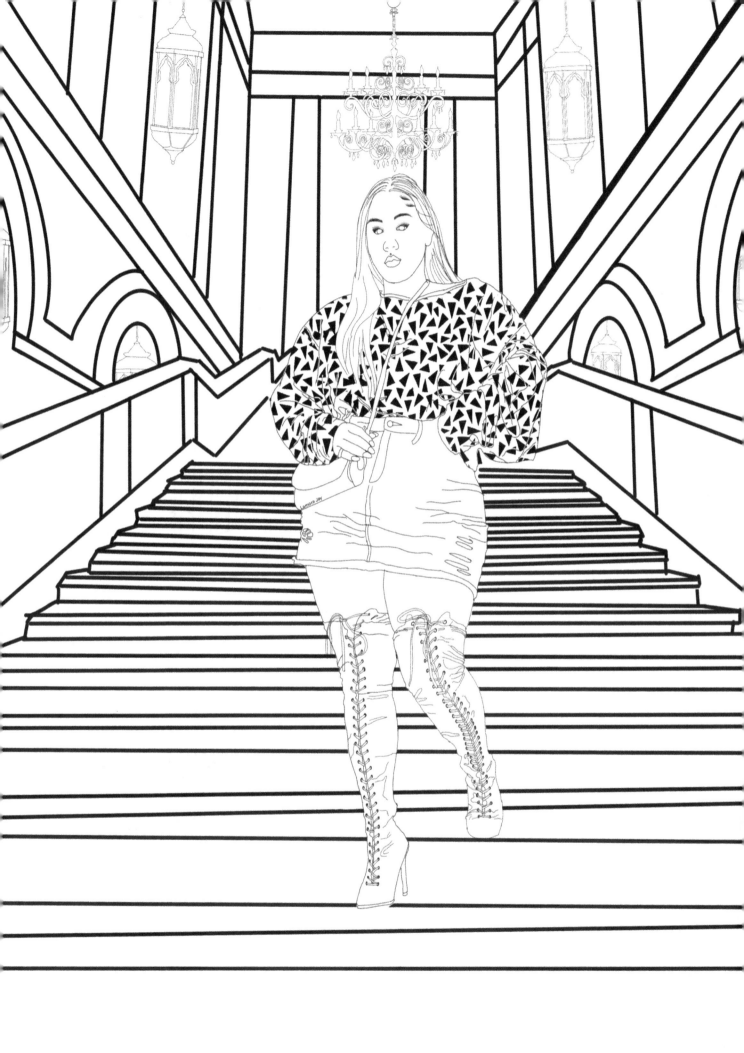

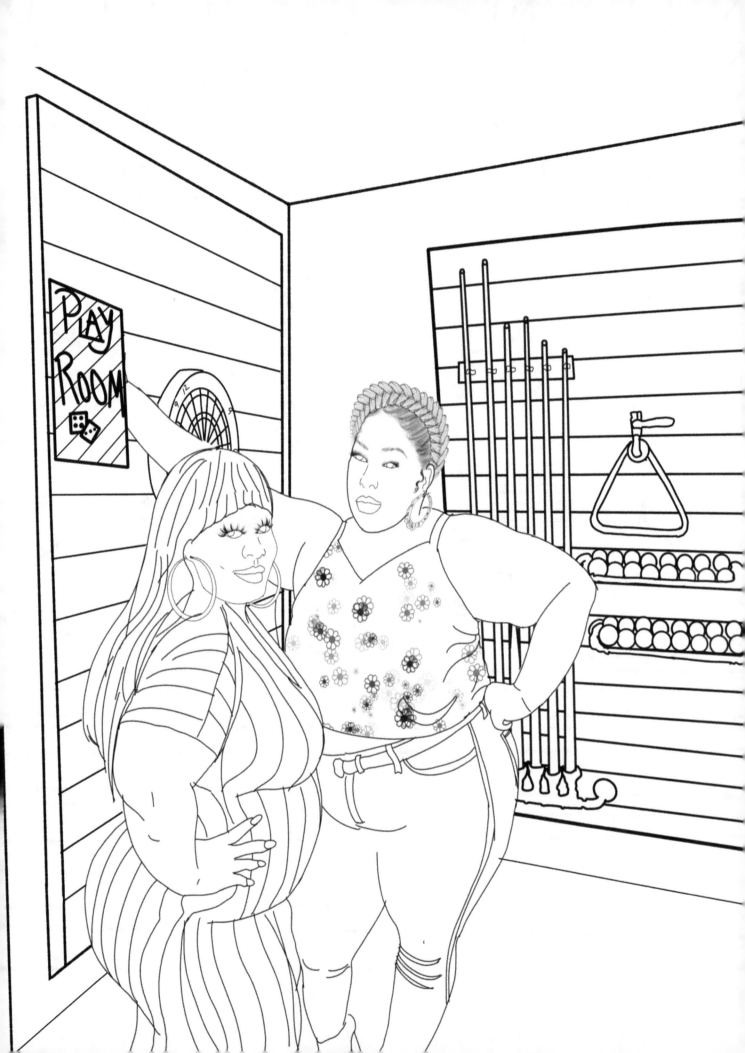

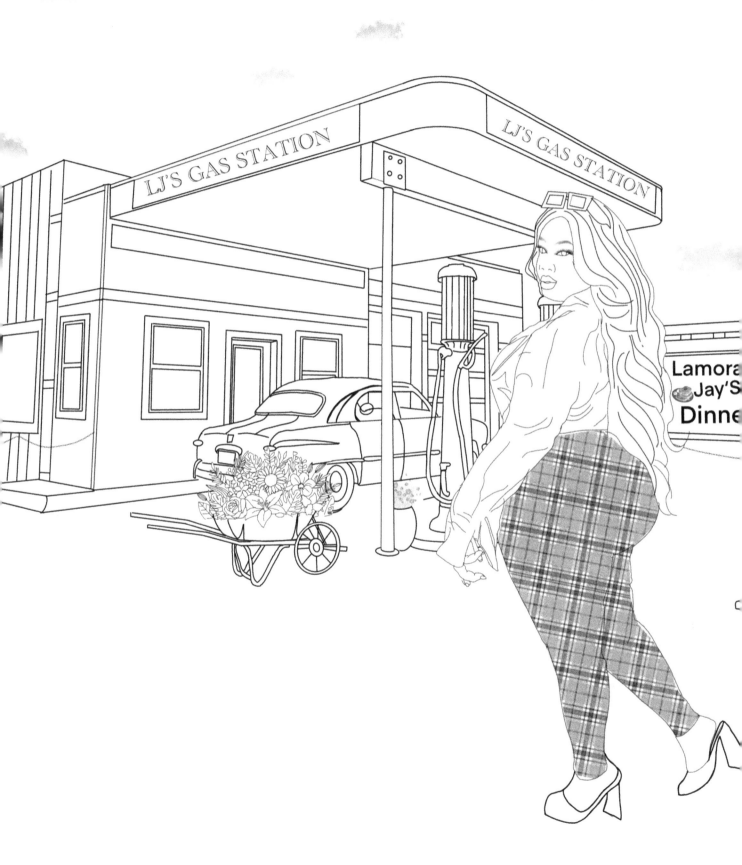

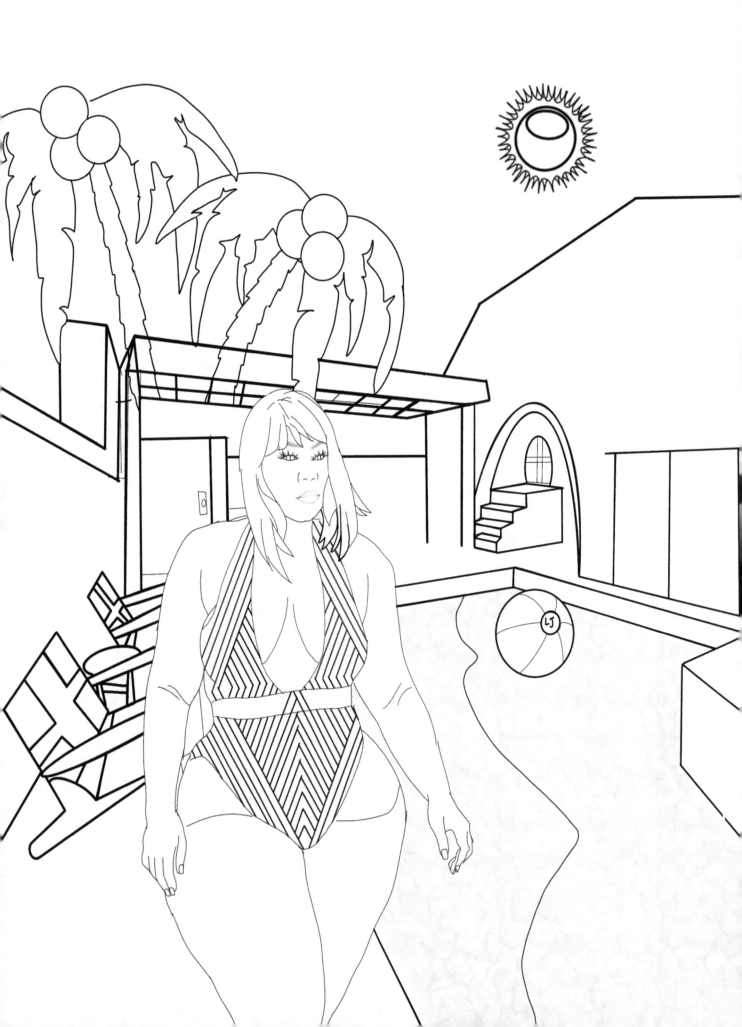

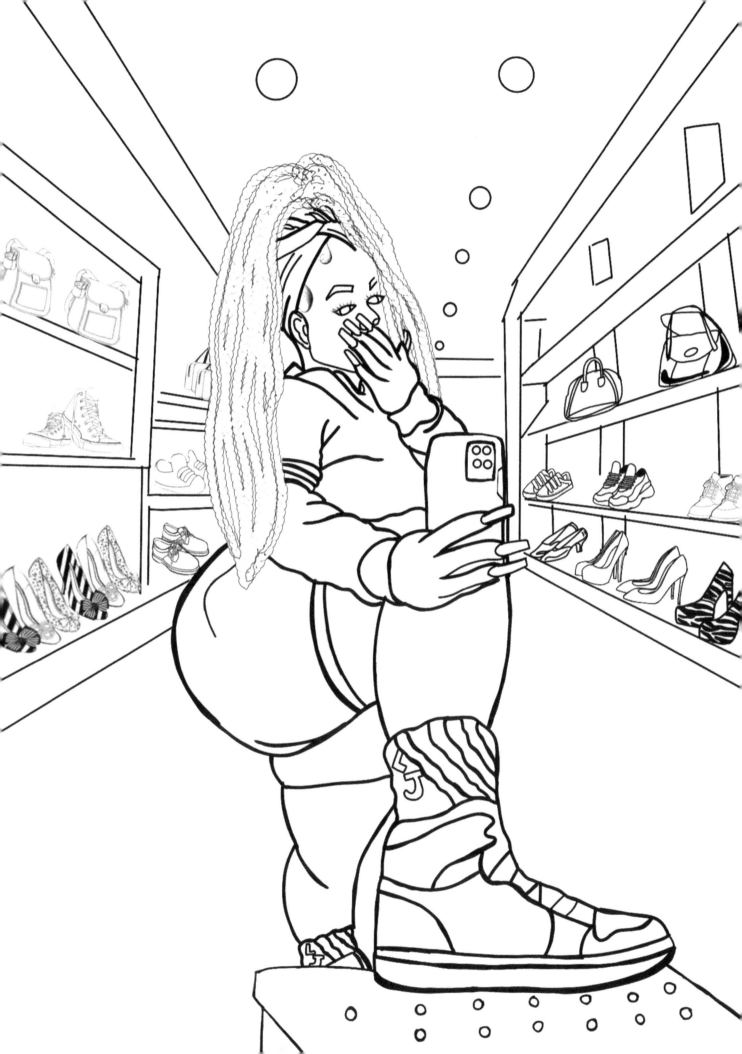

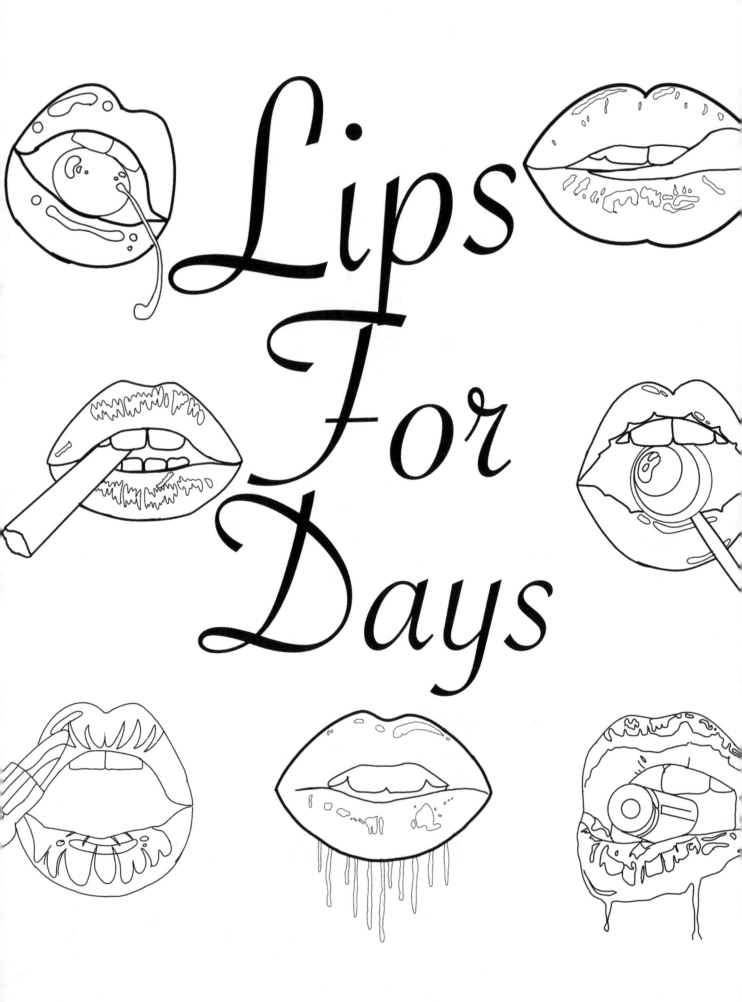

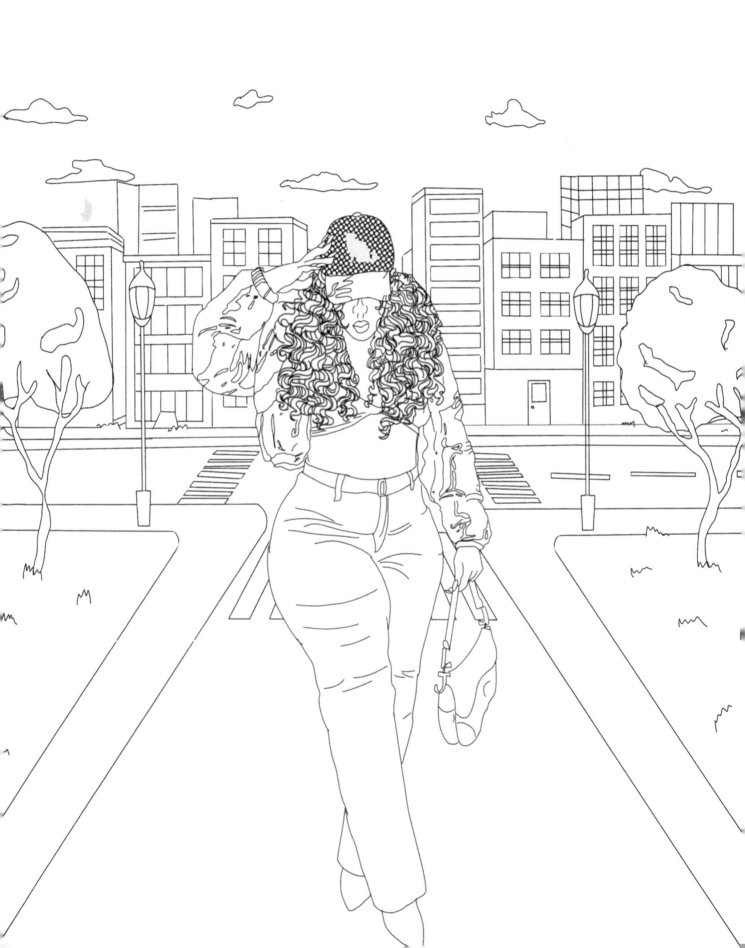

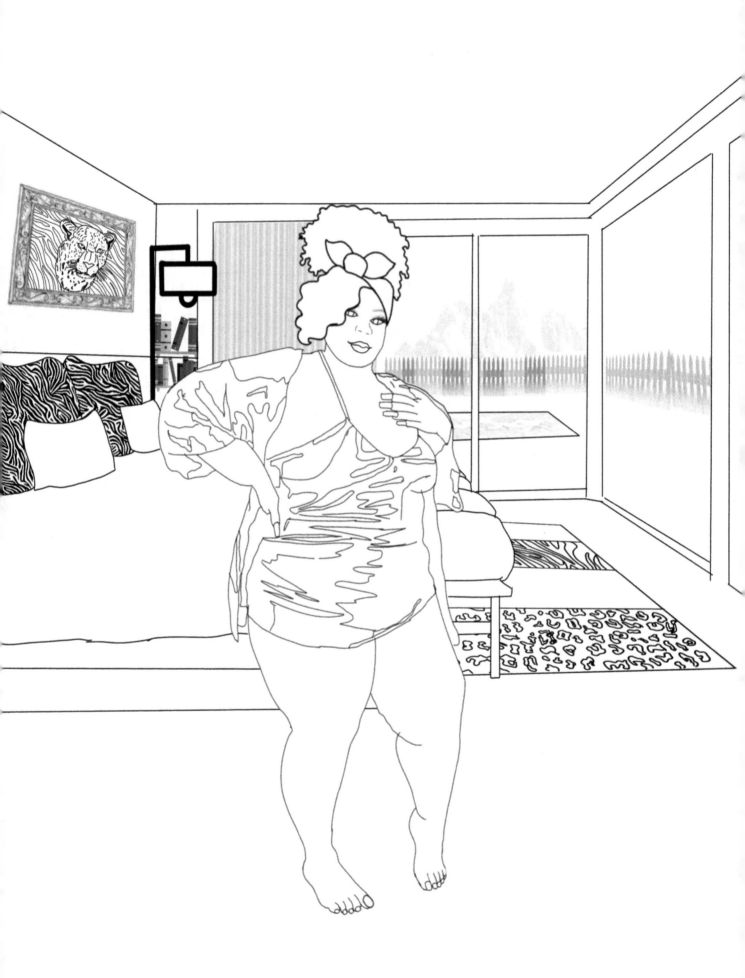

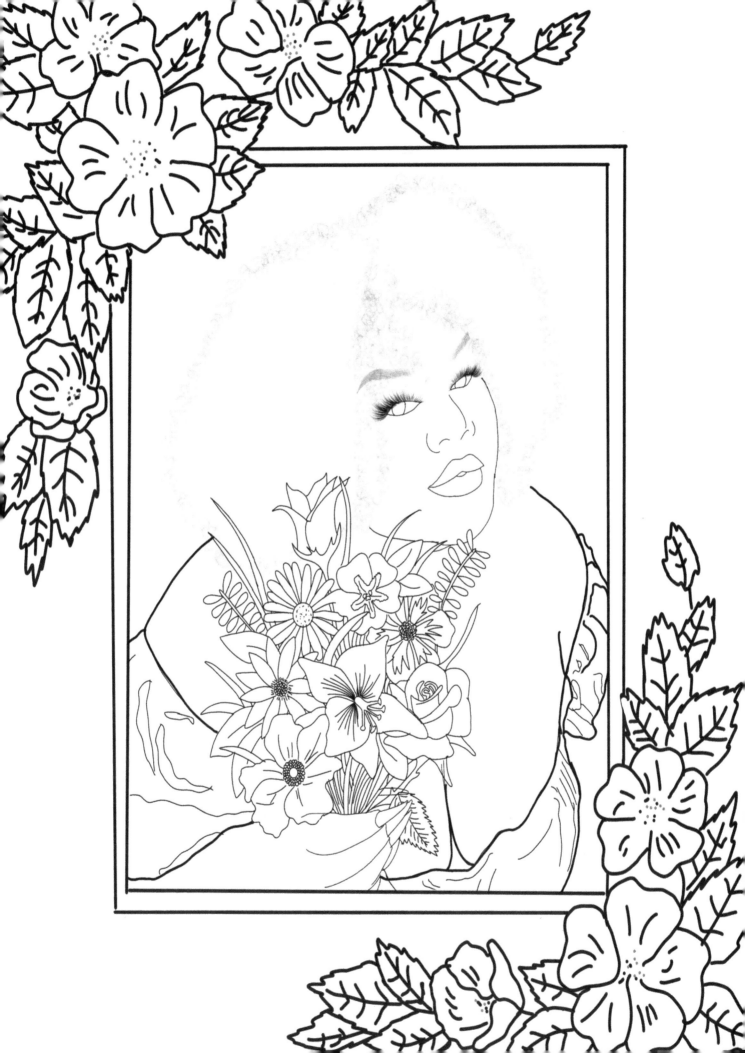

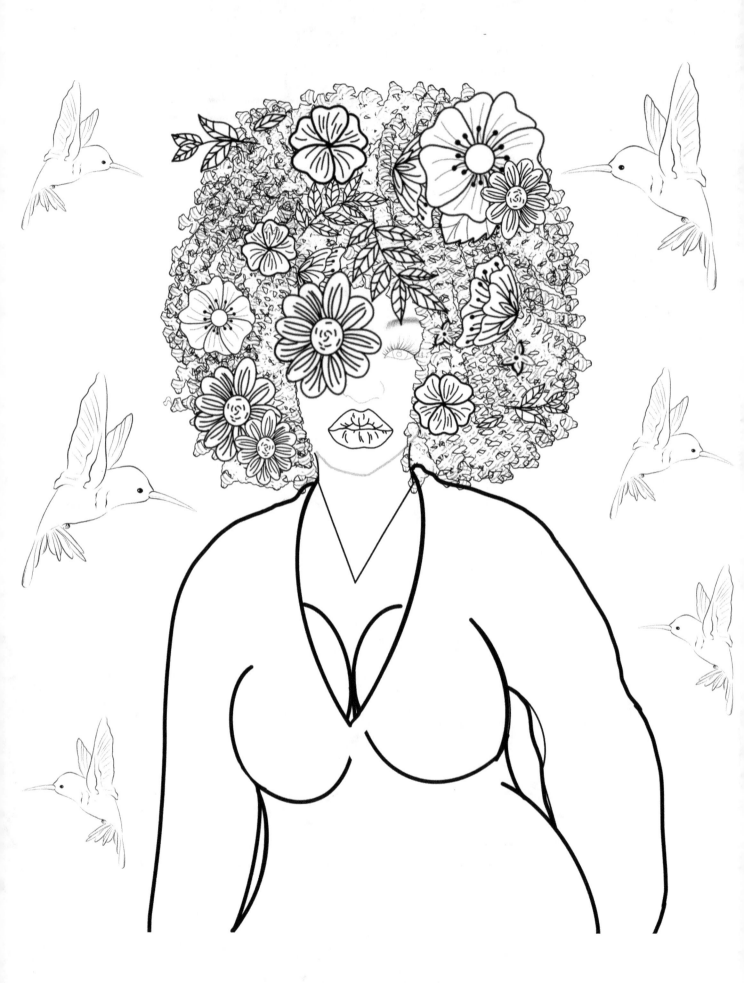

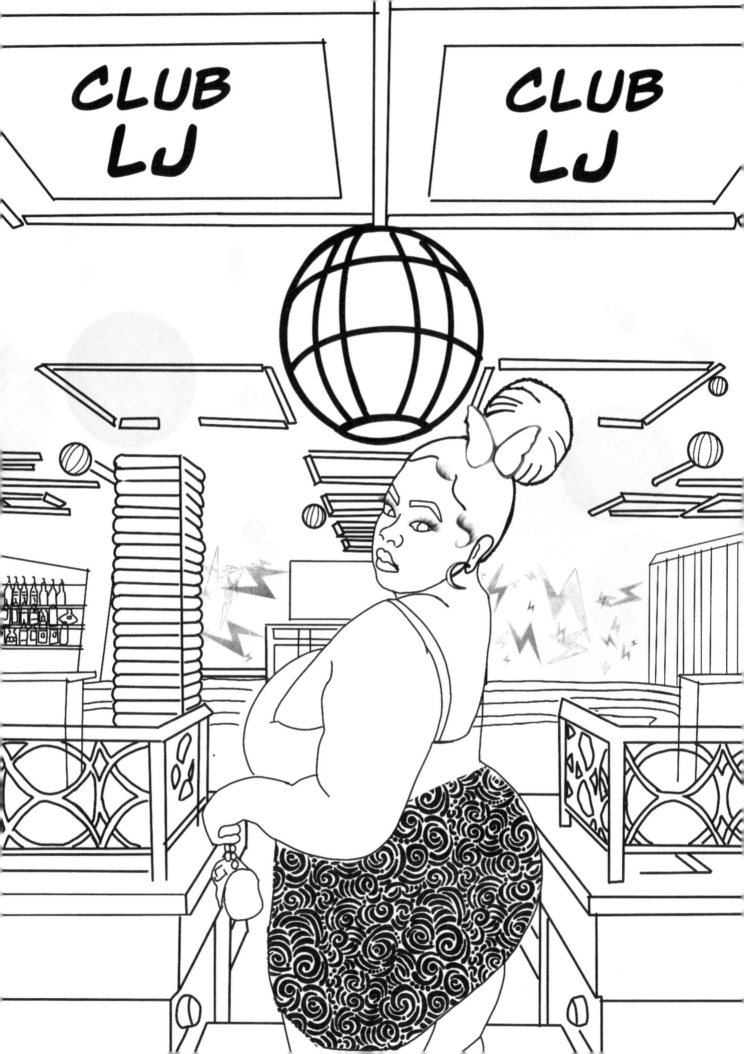

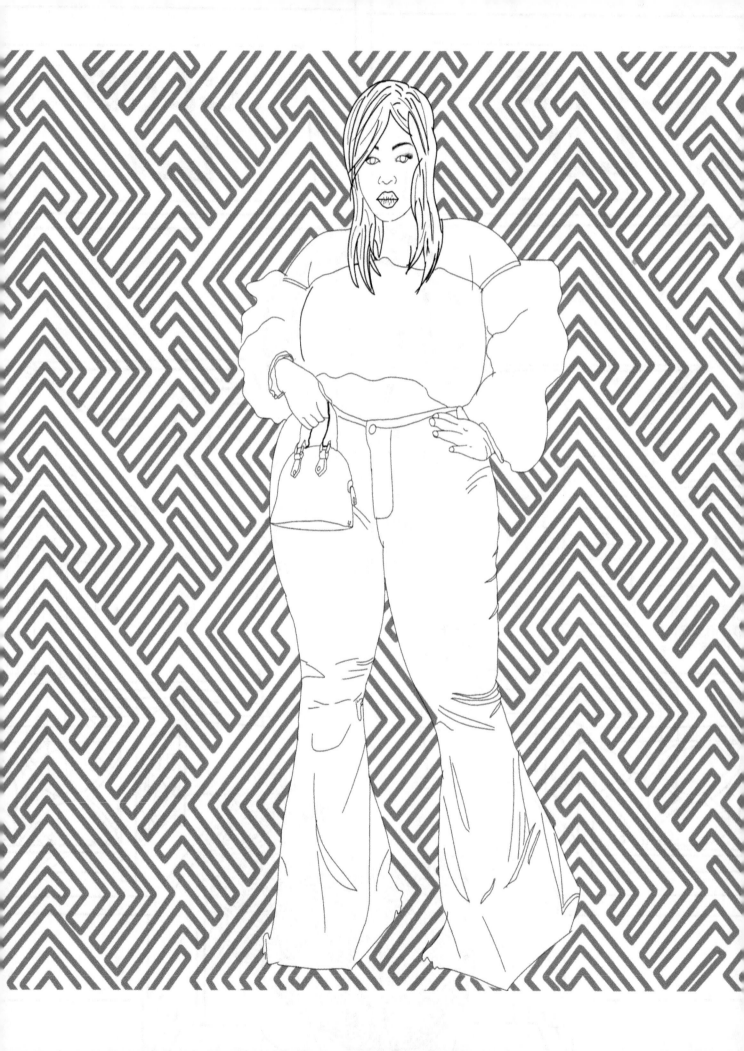

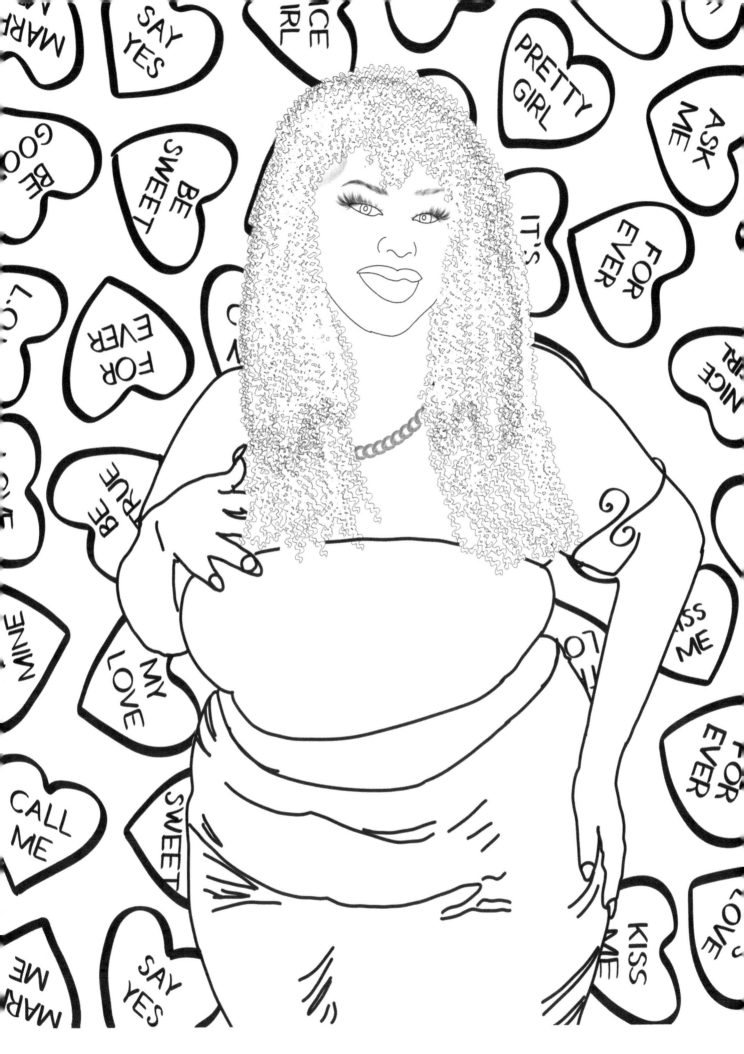

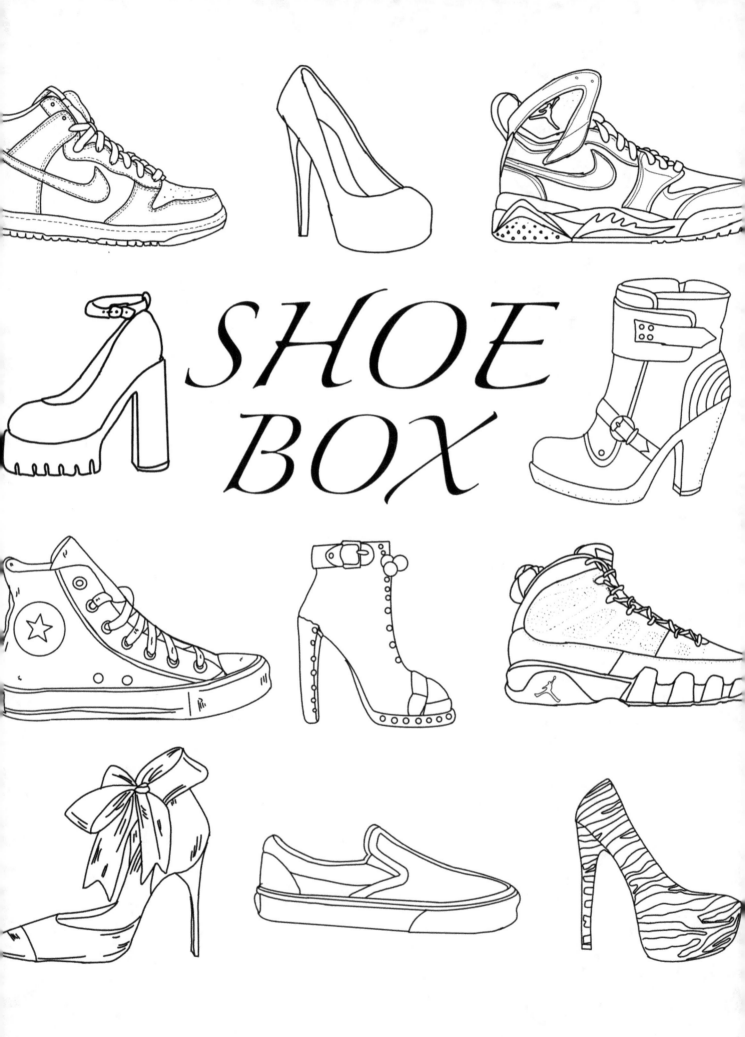

SHOE
BOX

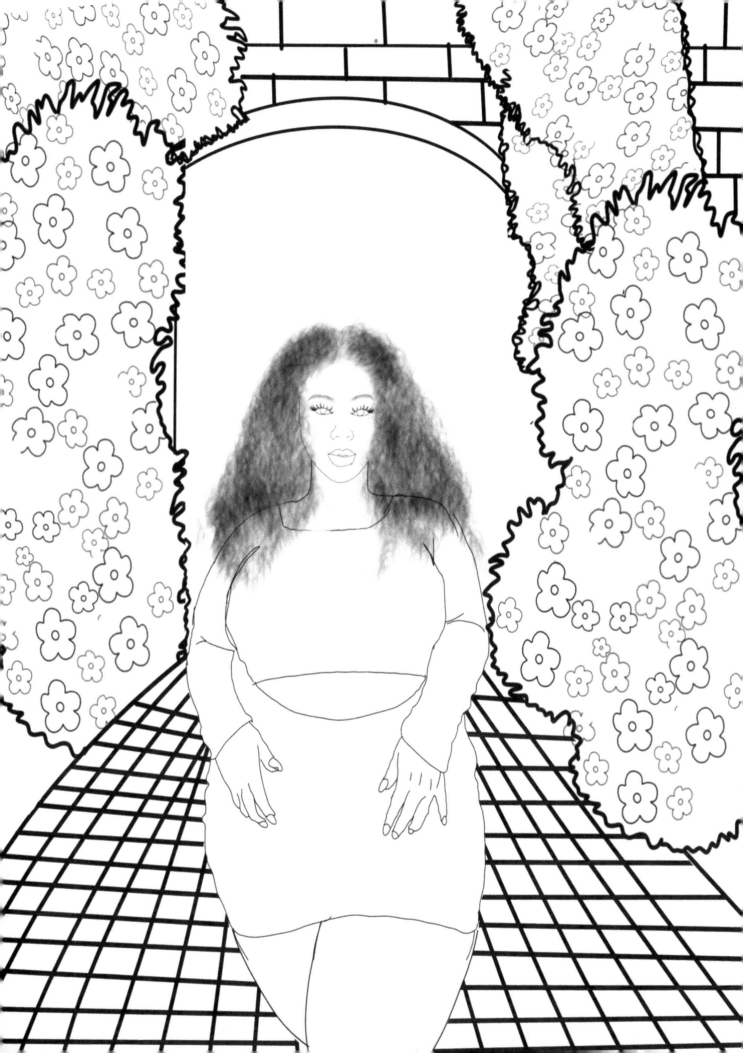

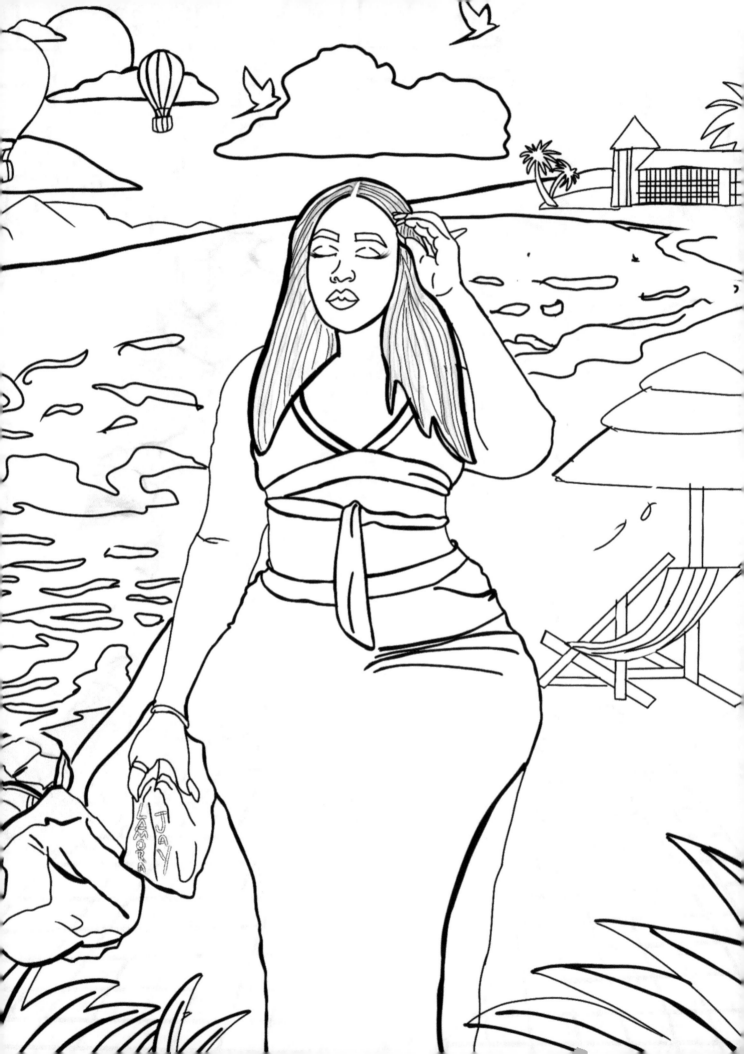

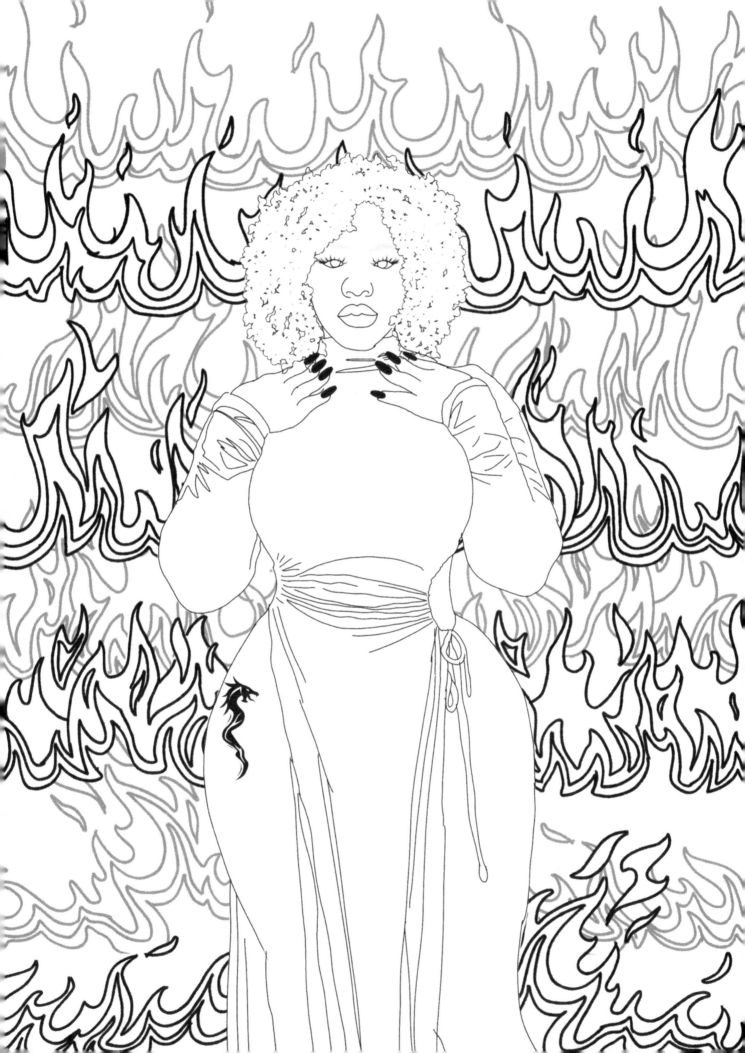

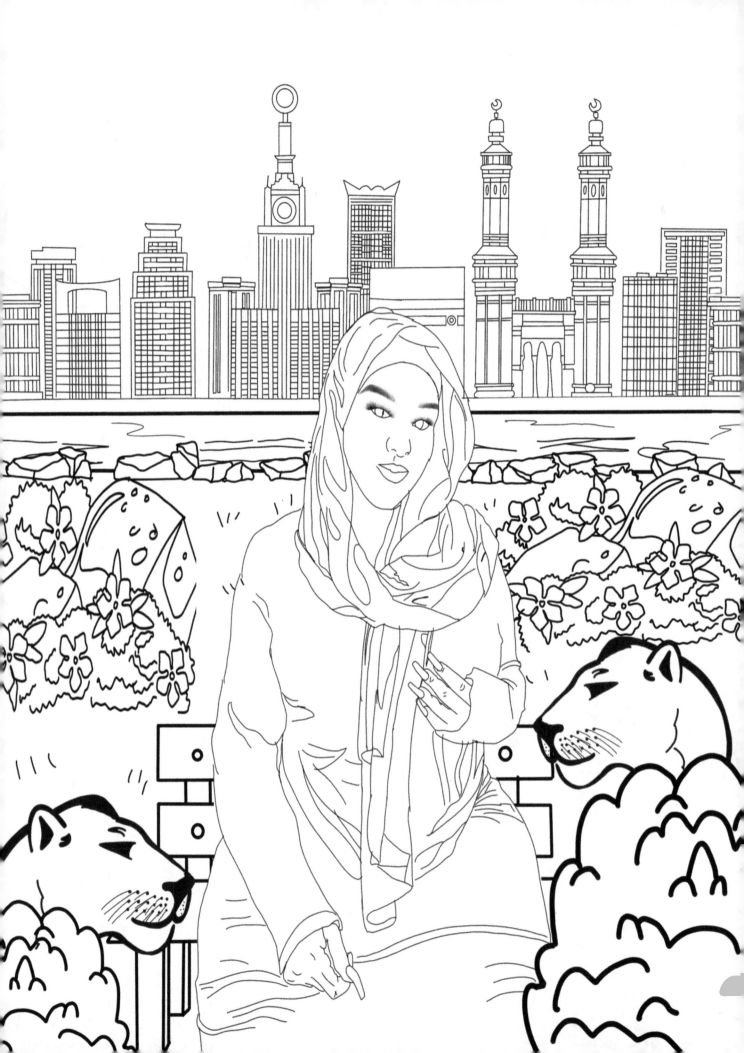

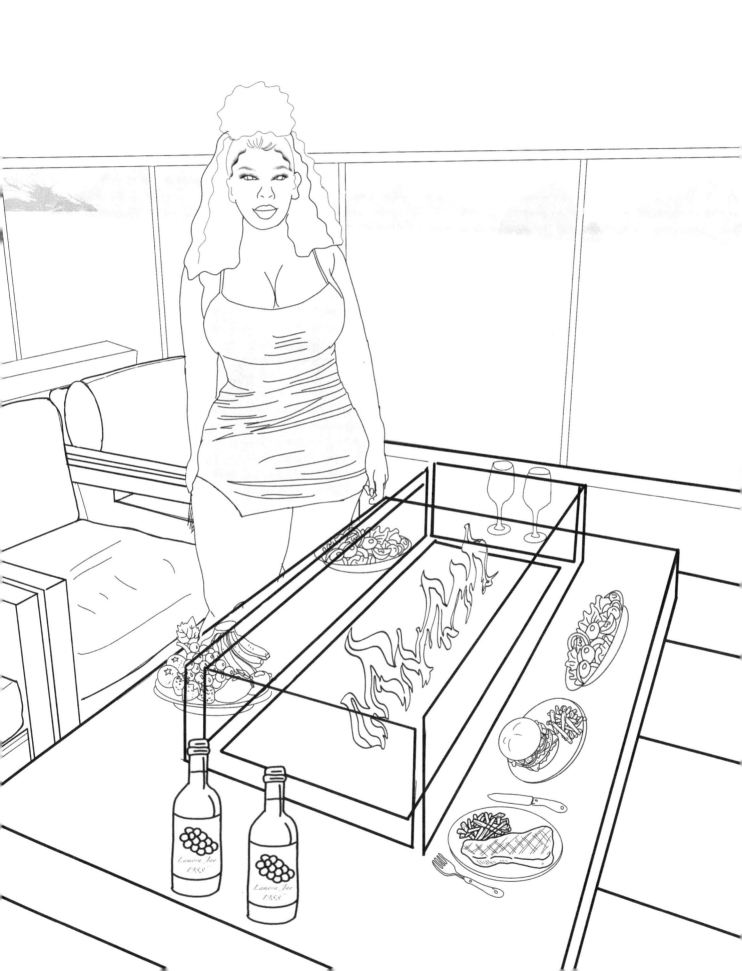

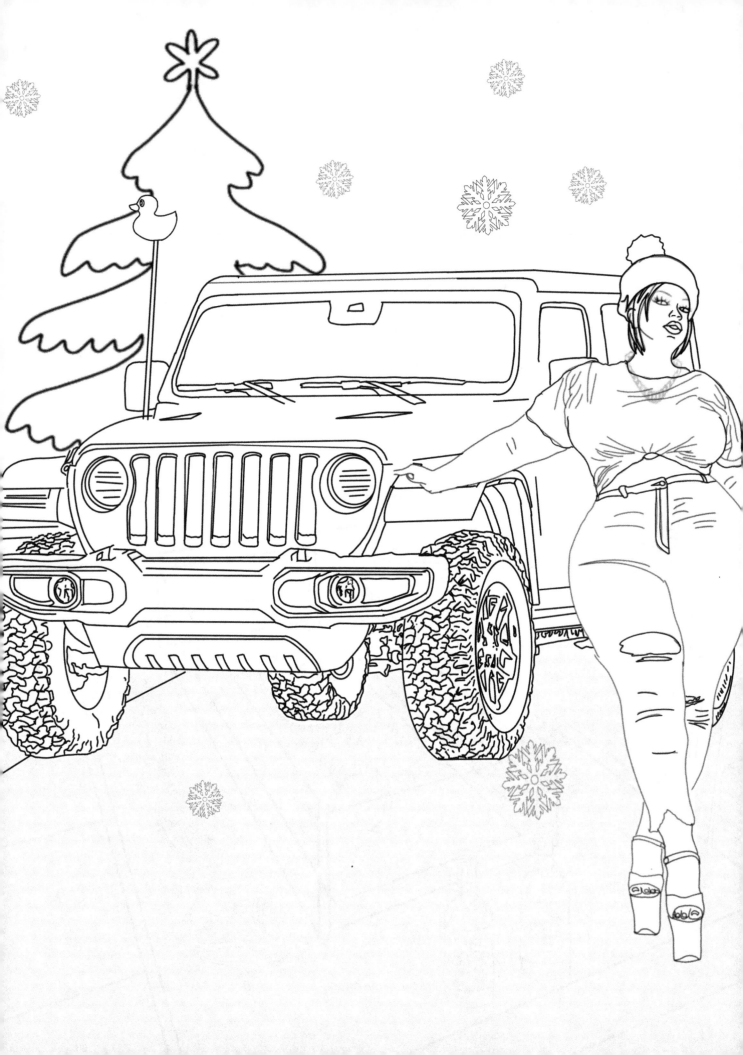

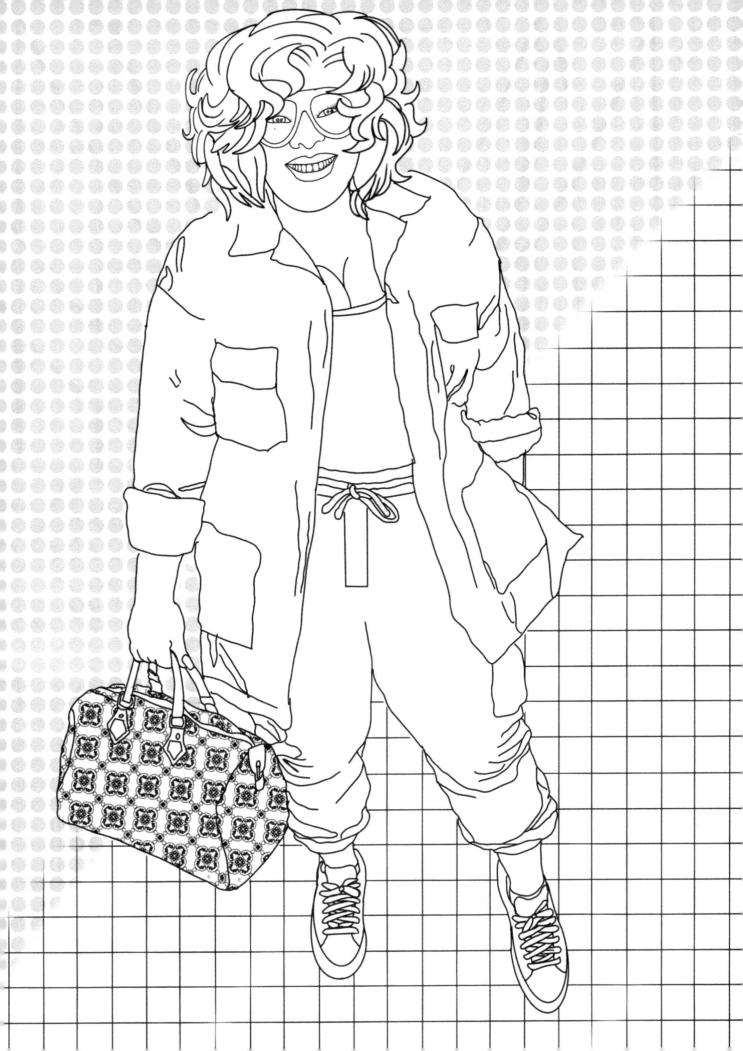

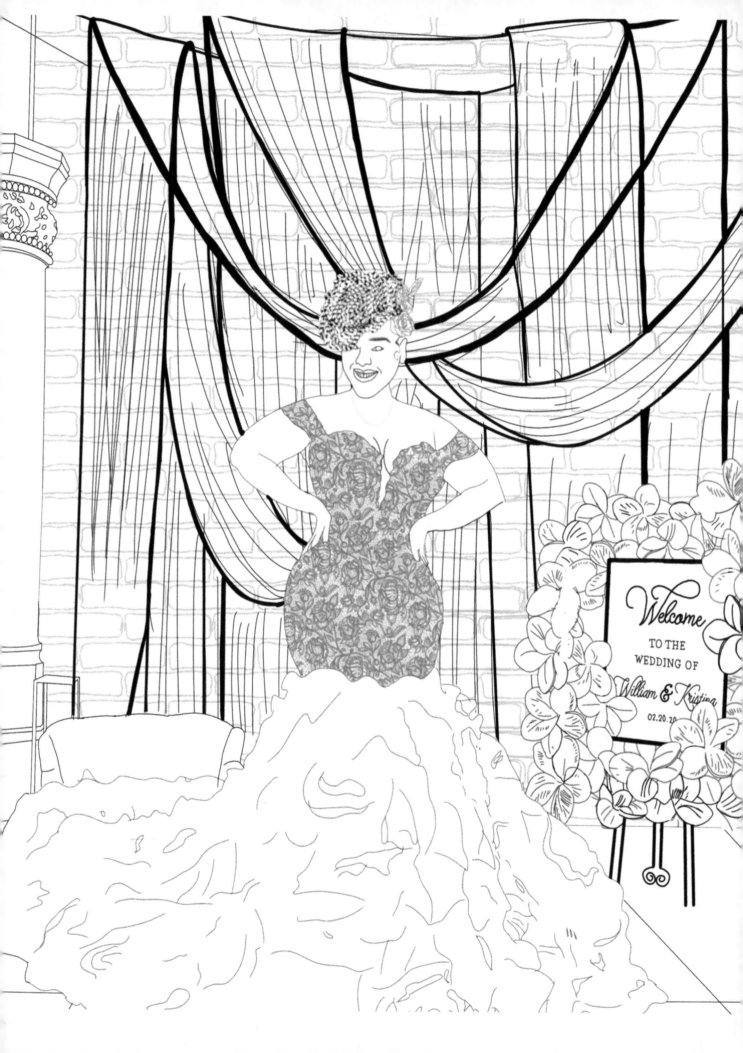

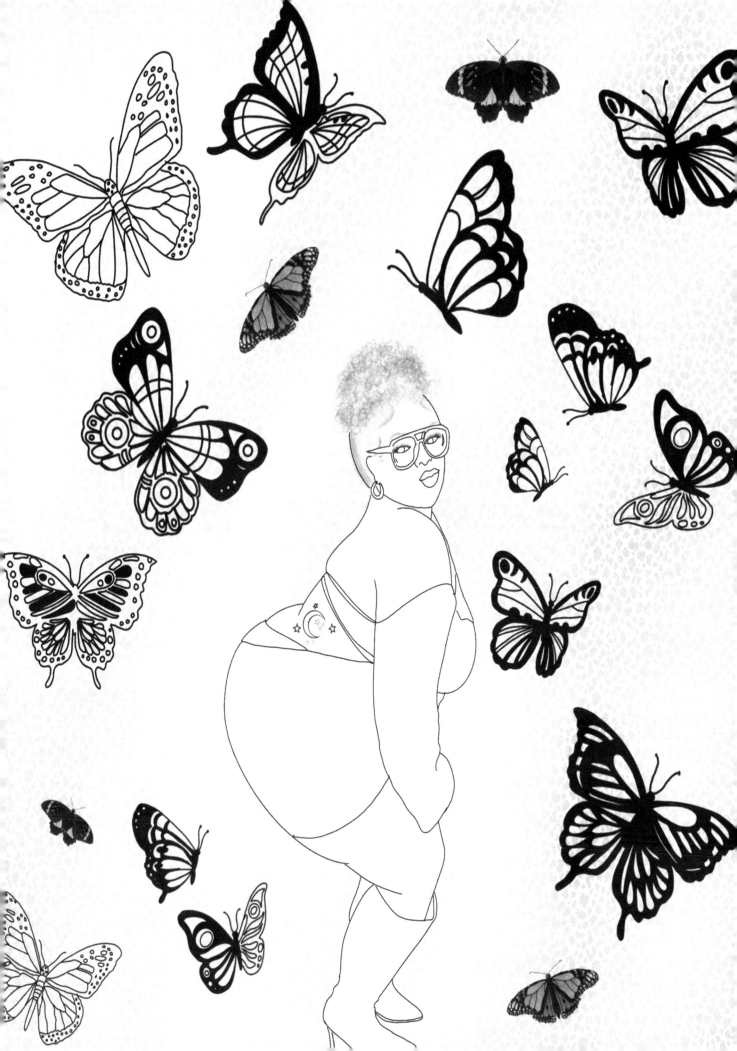

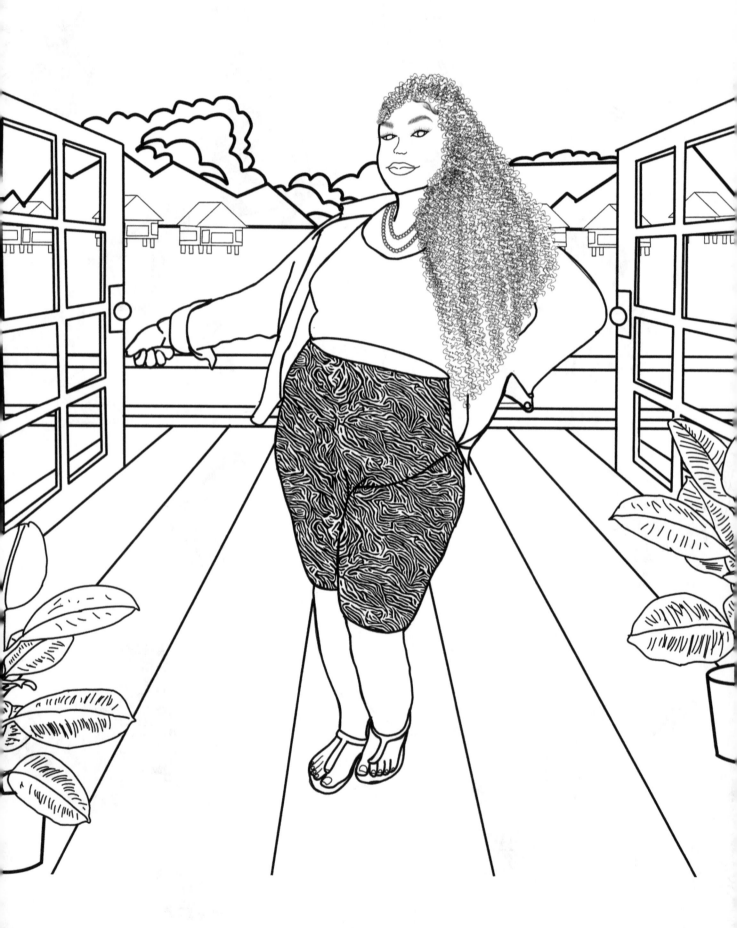

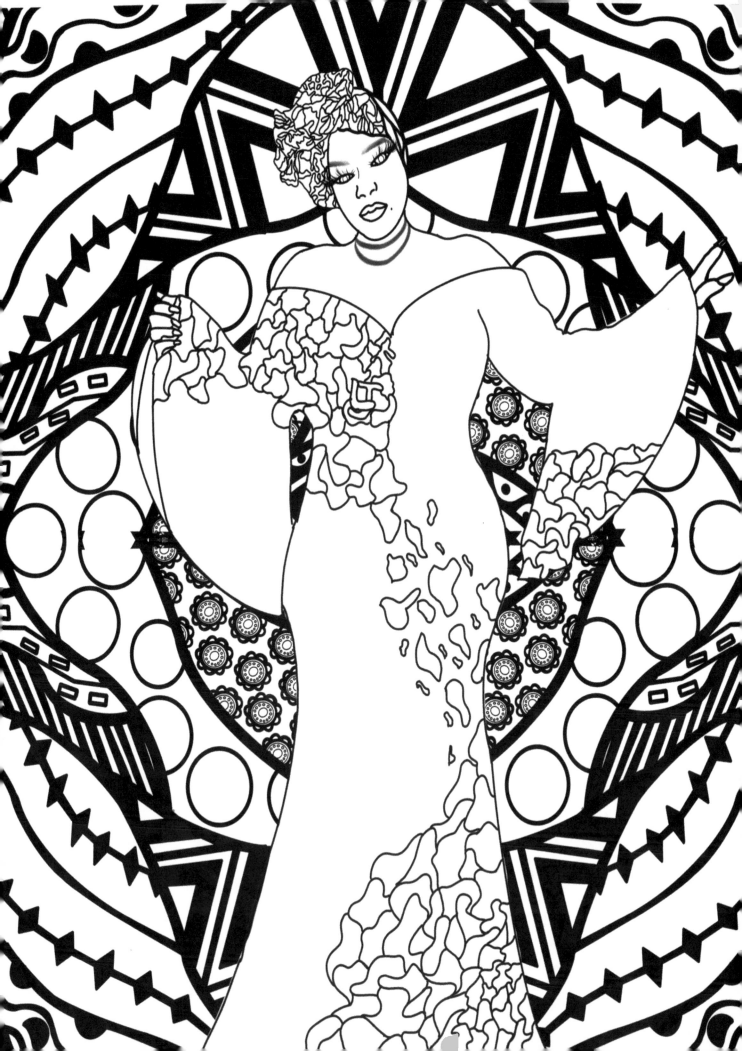

Printed in the USA
CPSIA information can be obtained
at www.ICGtesting.com
LVHW061506230823
755929LV00012B/336

LAMORA JAY

BBW

BEAUTIFUL BLACK WOMEN COLORING BOOK

LAMORA JAY LLC.

To our valued customers

Thank you for choosing our coloring book! We appreciate your support, it helps us stay motivated and wanting to create more books. We can't wait to see what you have created.
Please send us your finished work and you may be seen on our page.

Instagram: Lamorajayllc

THIS BOOK BELONGS TO

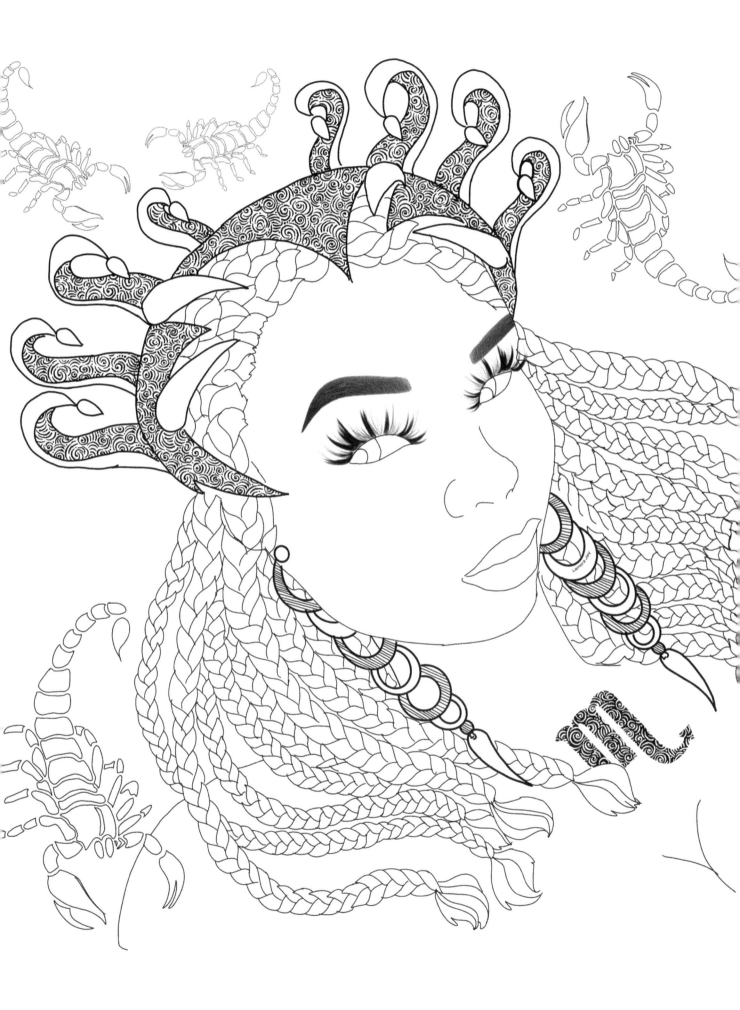

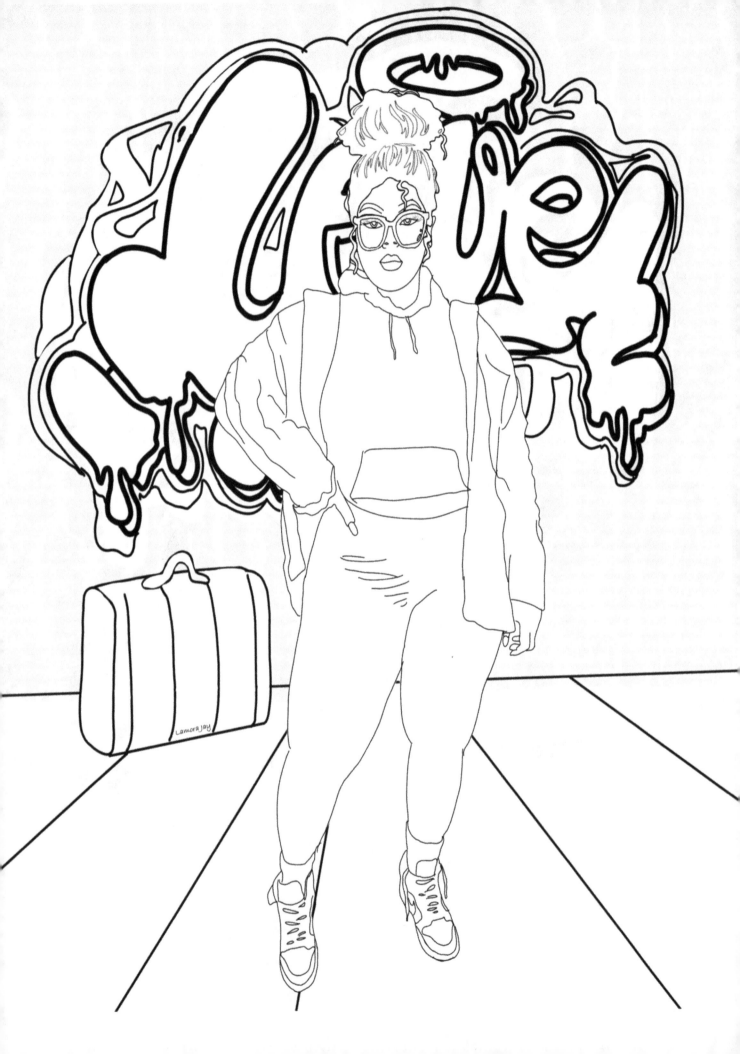

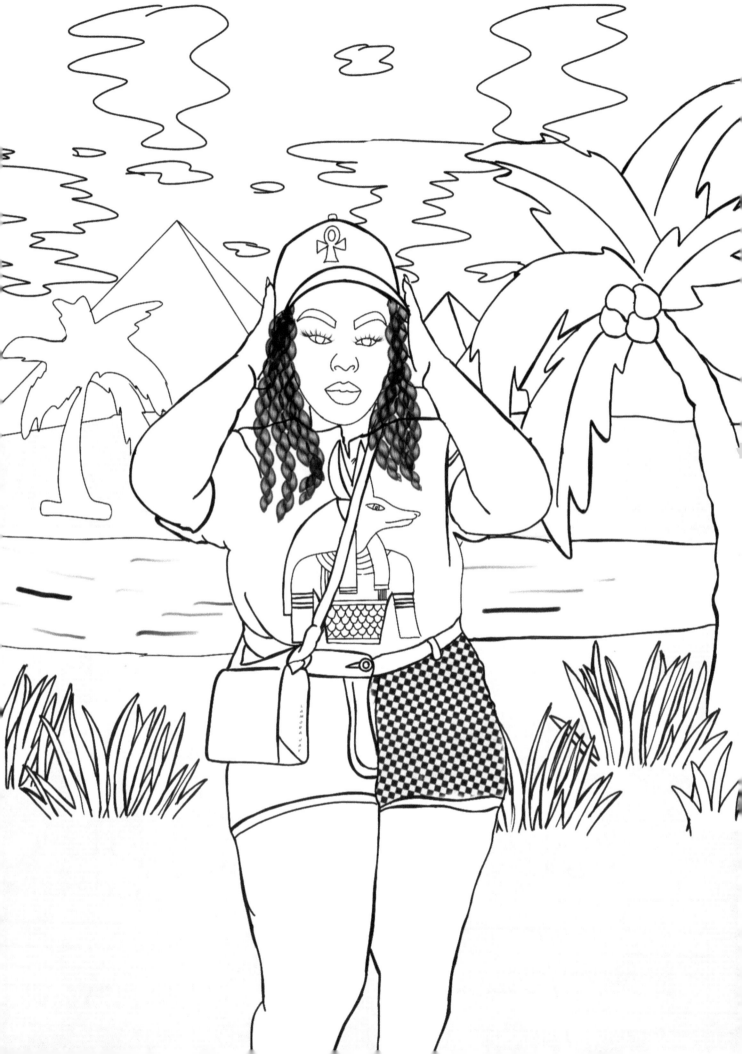

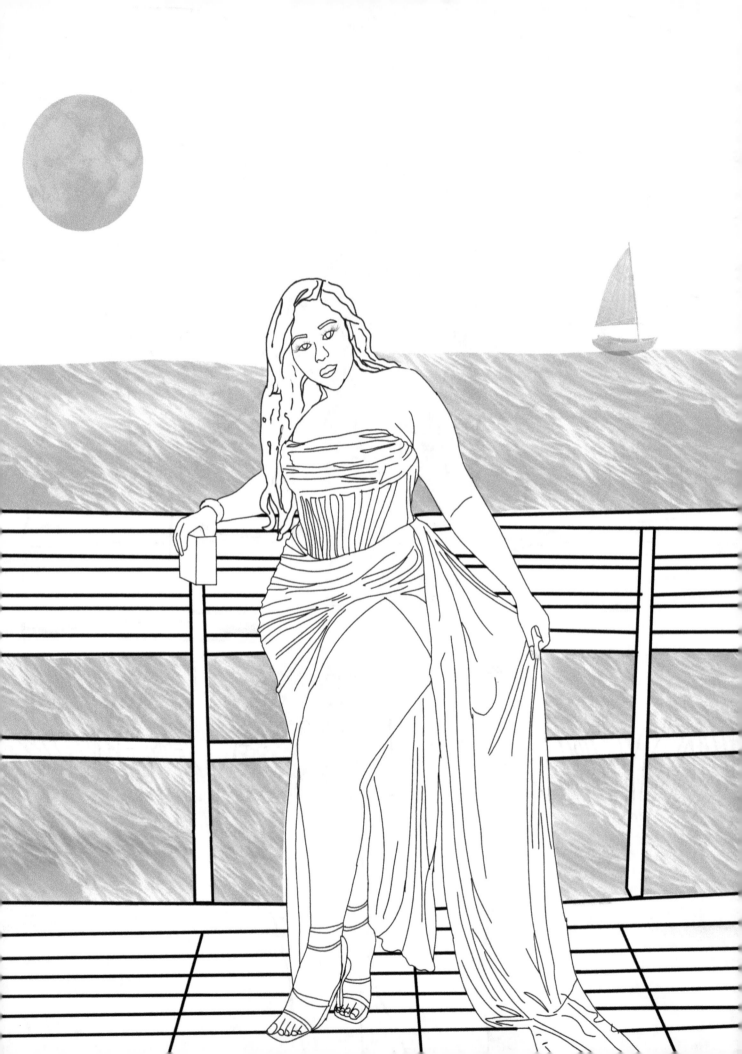

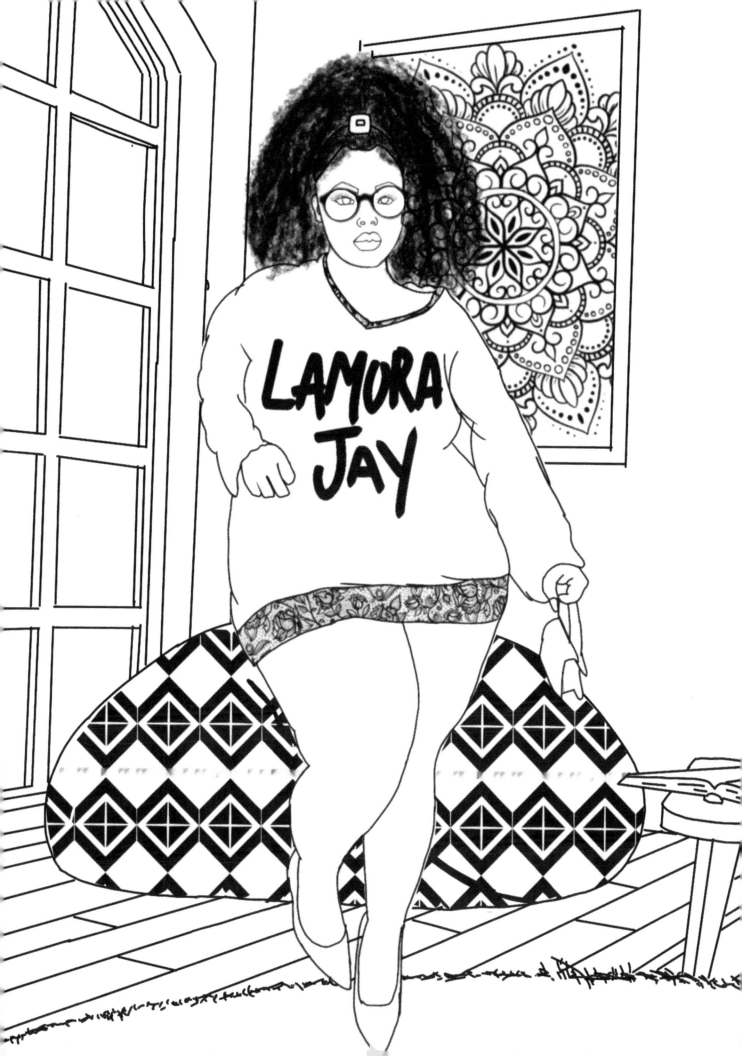

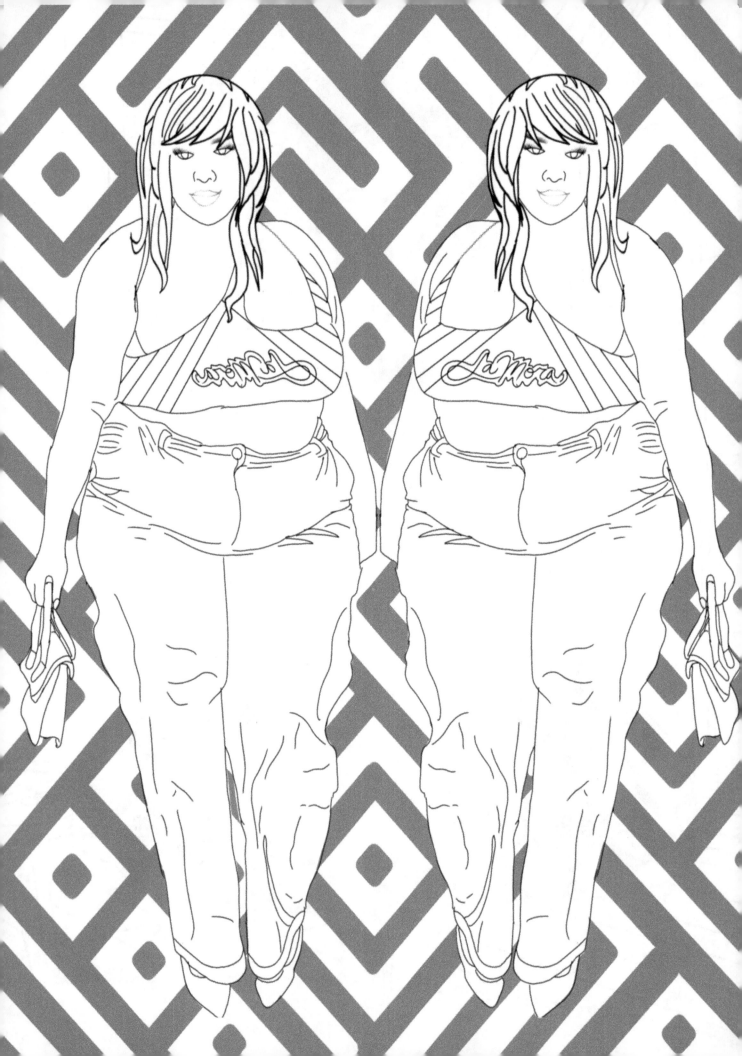

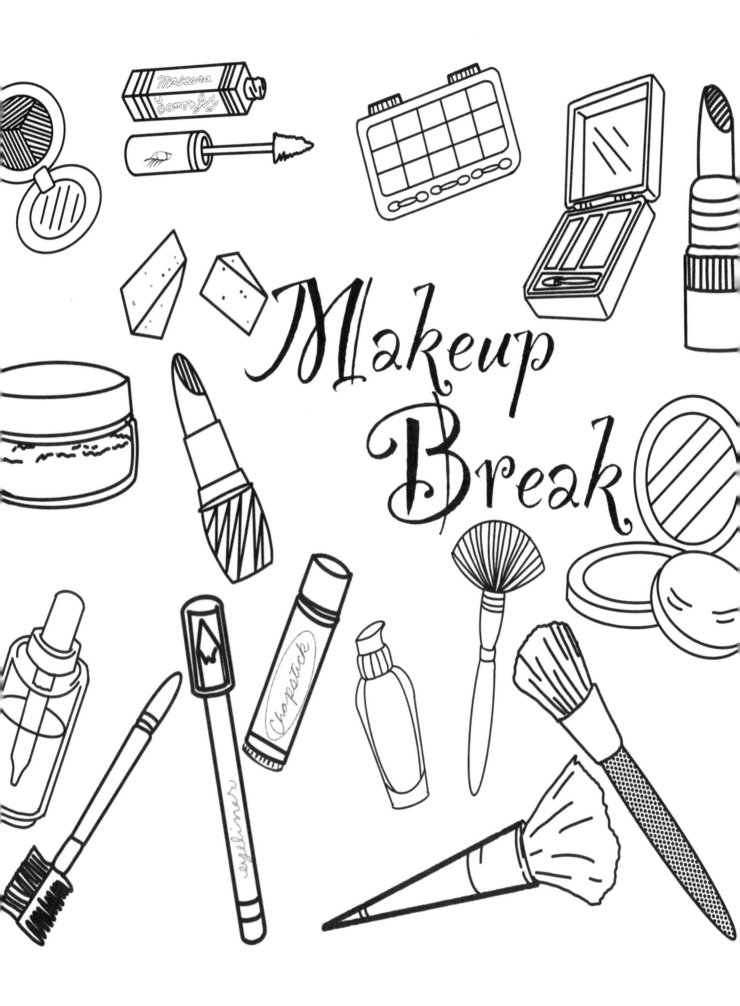

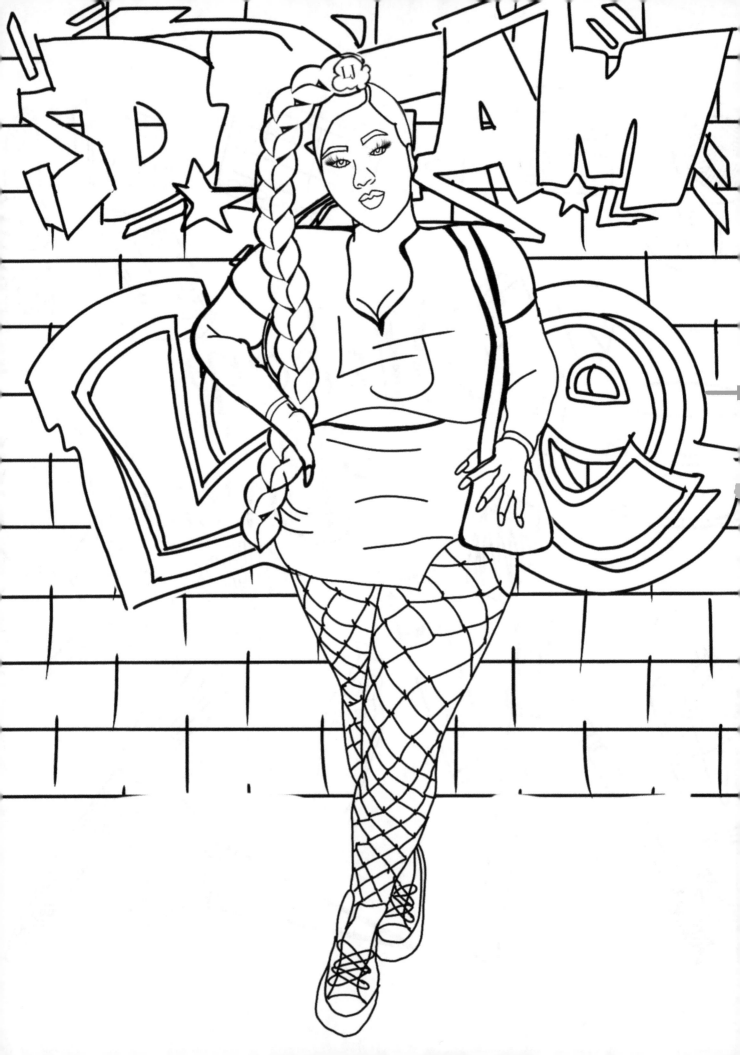

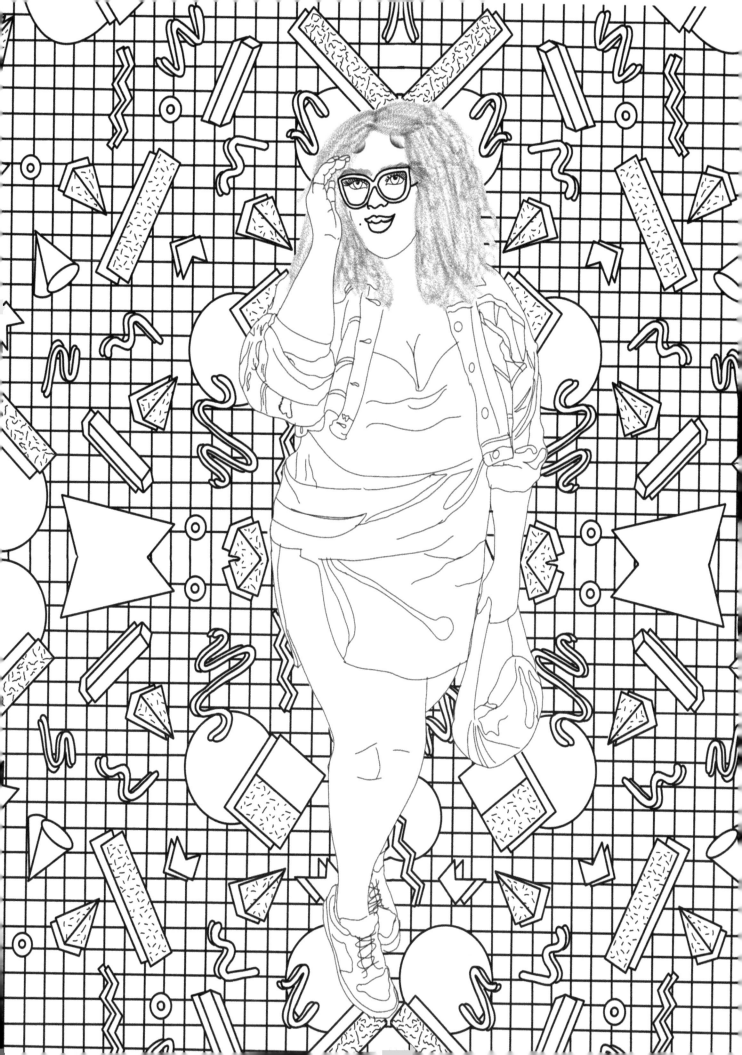

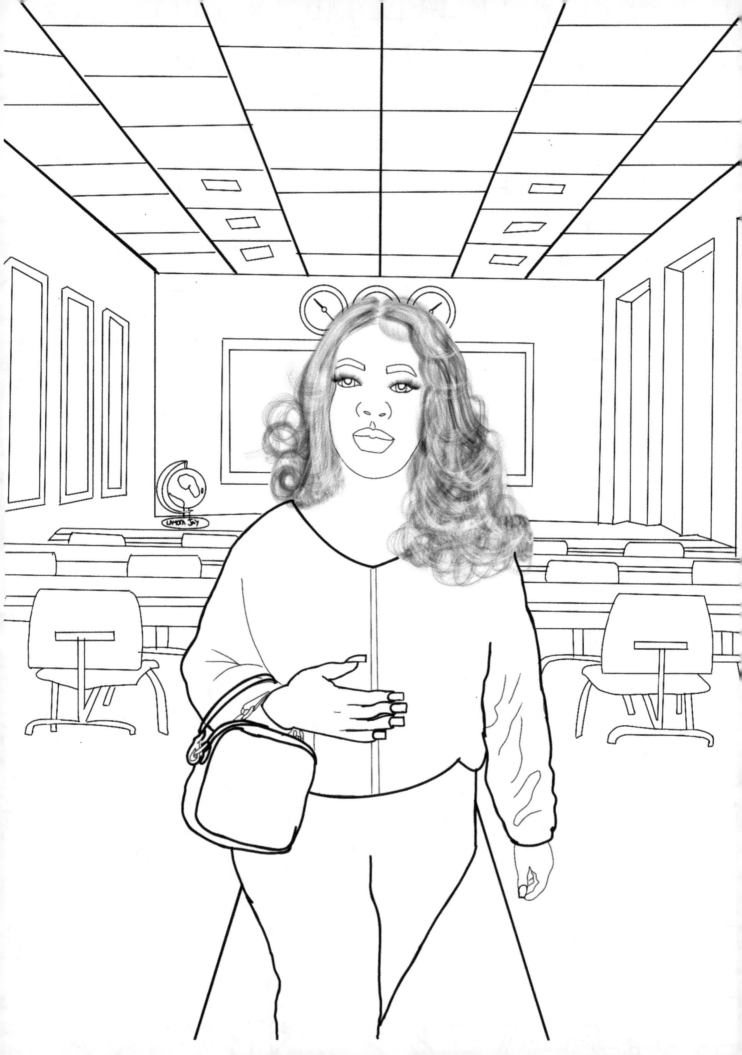

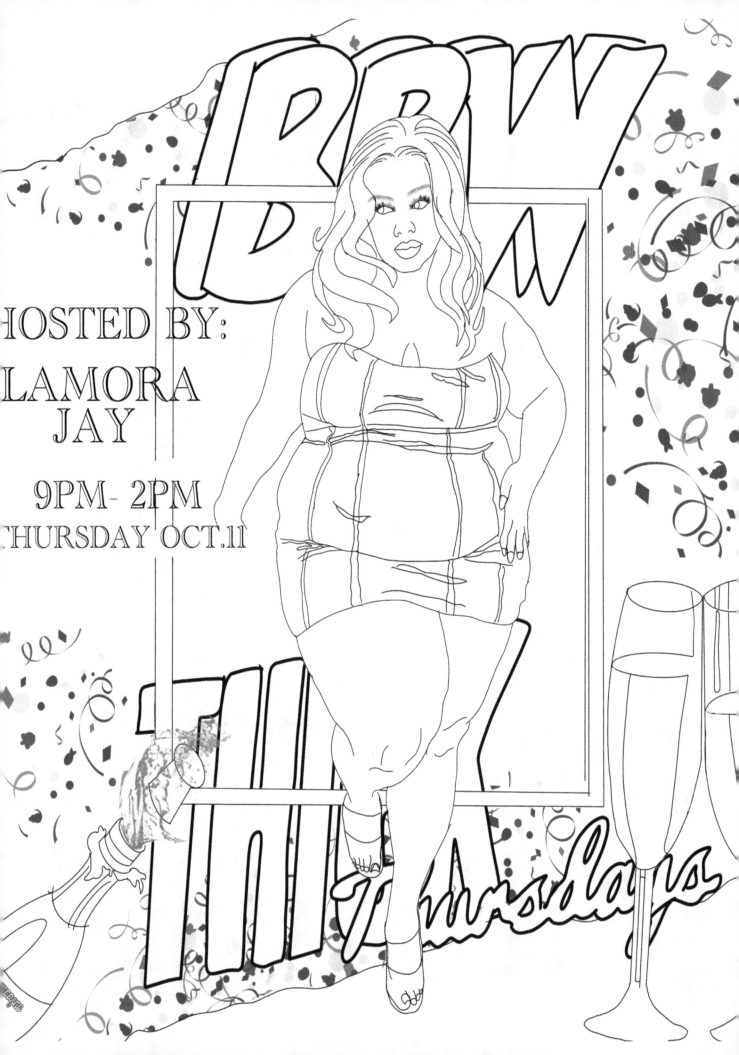

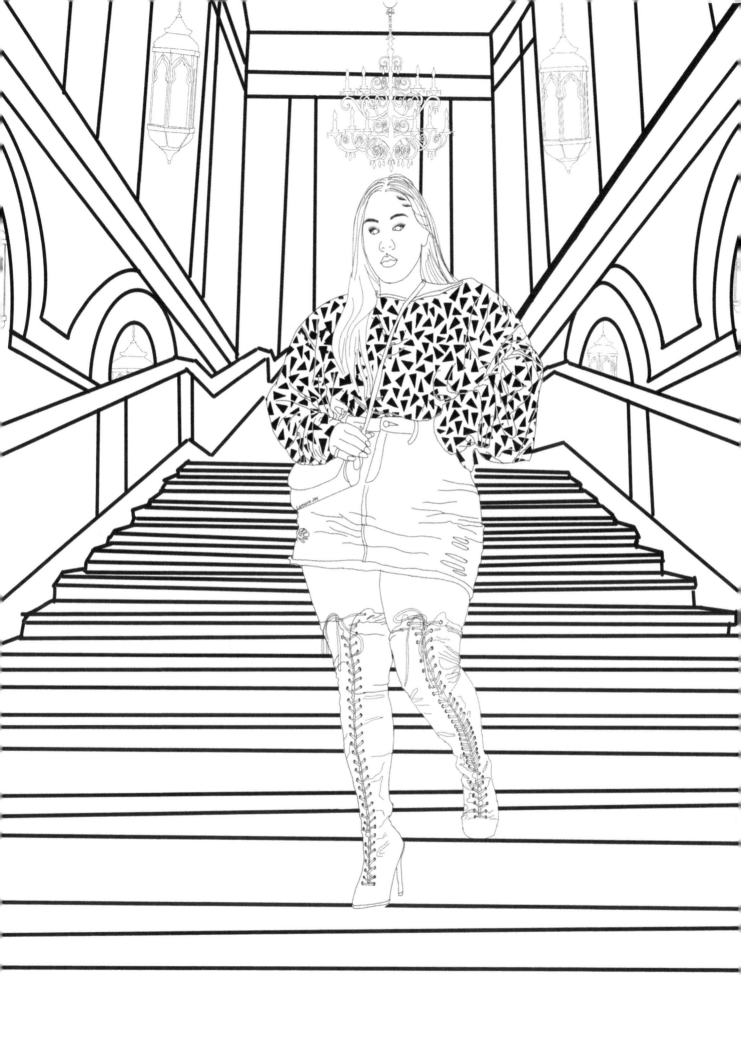

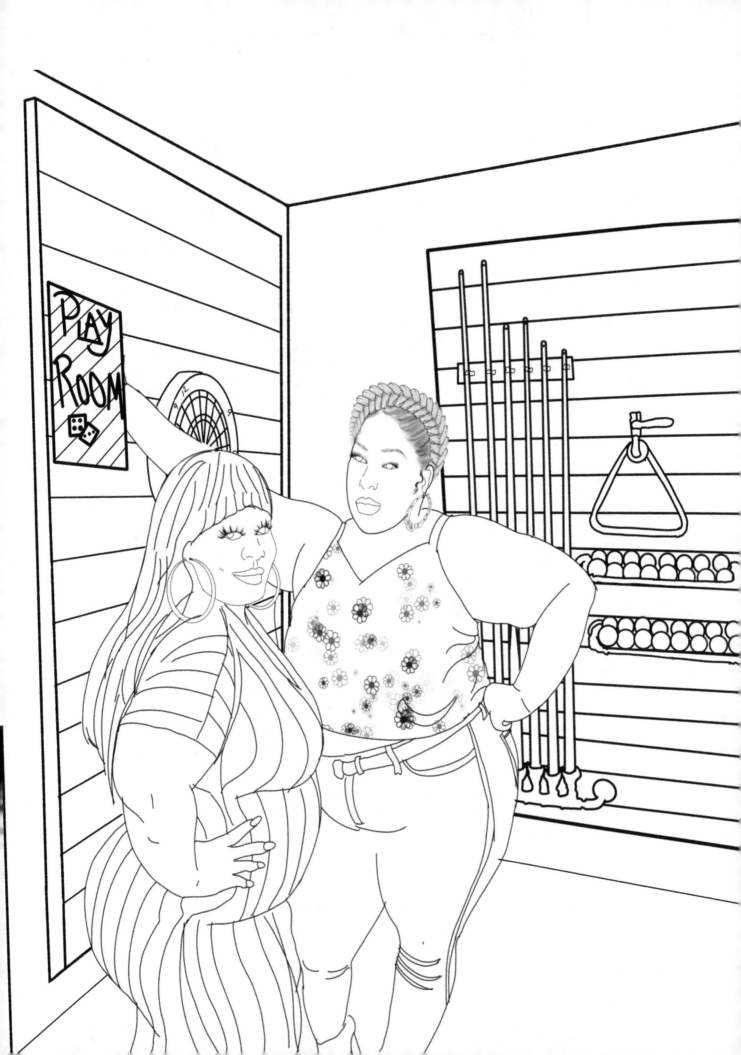

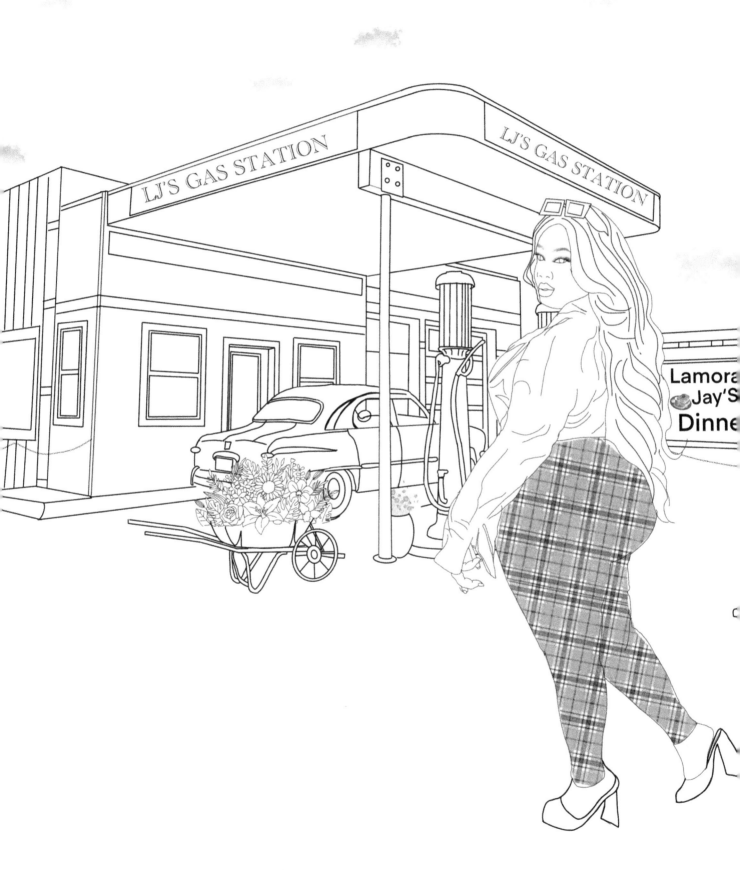

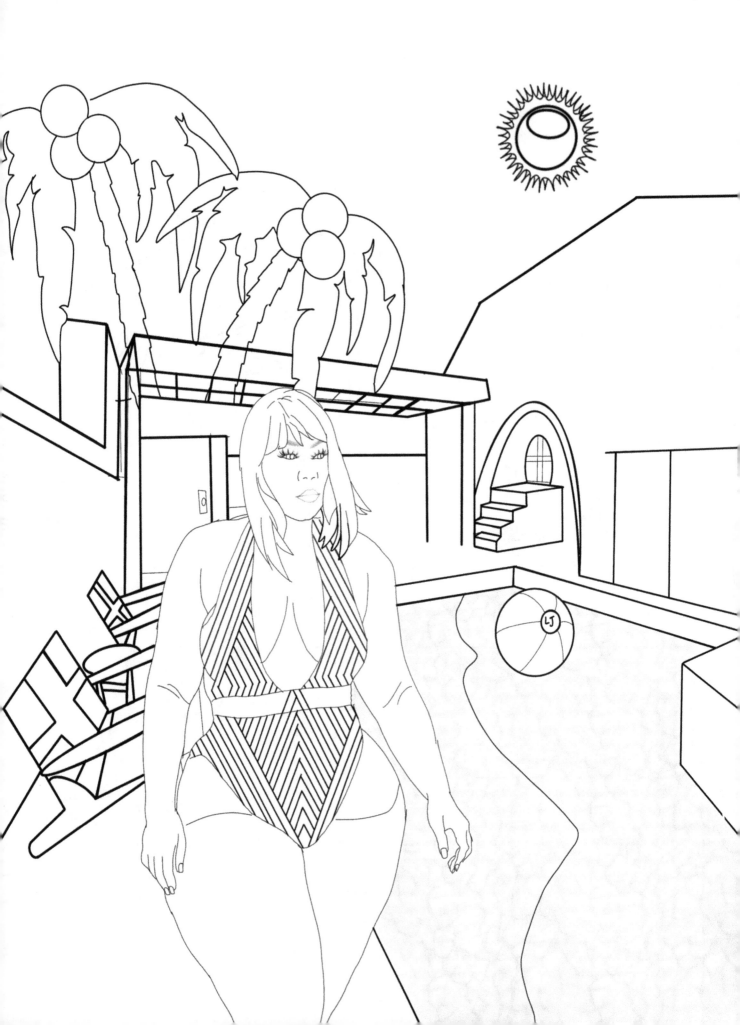

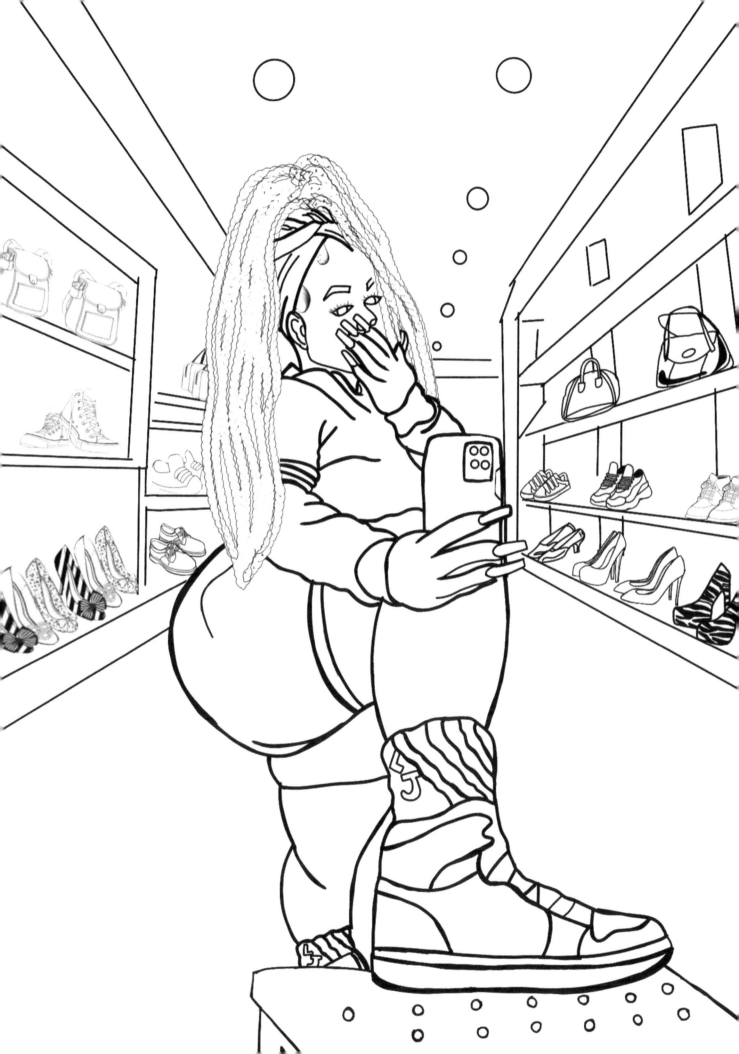

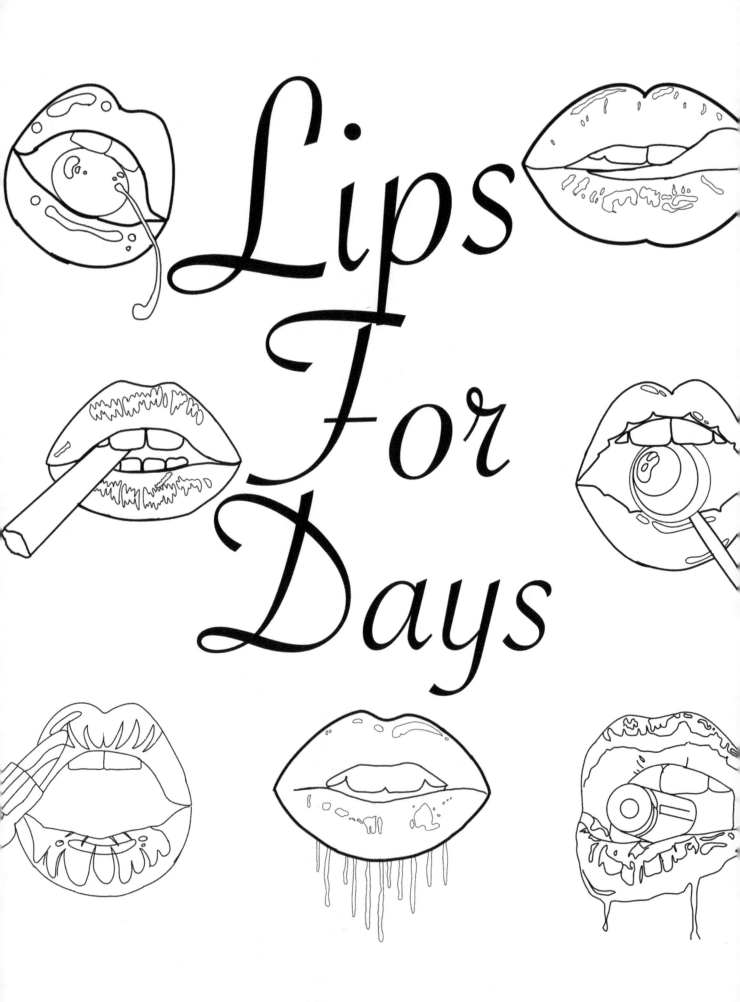

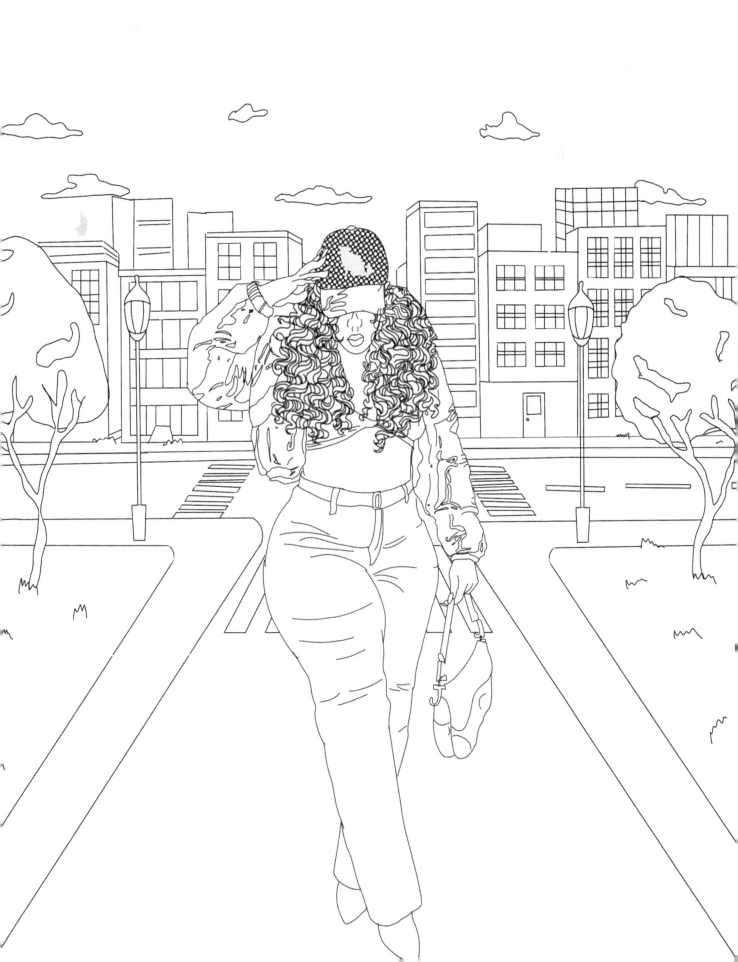

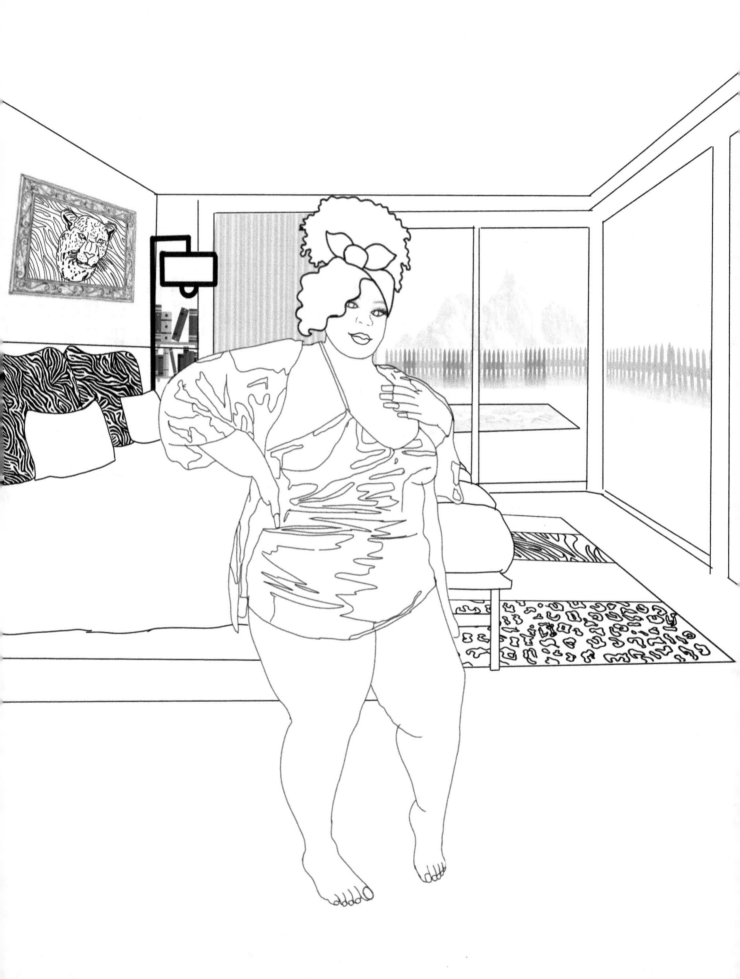

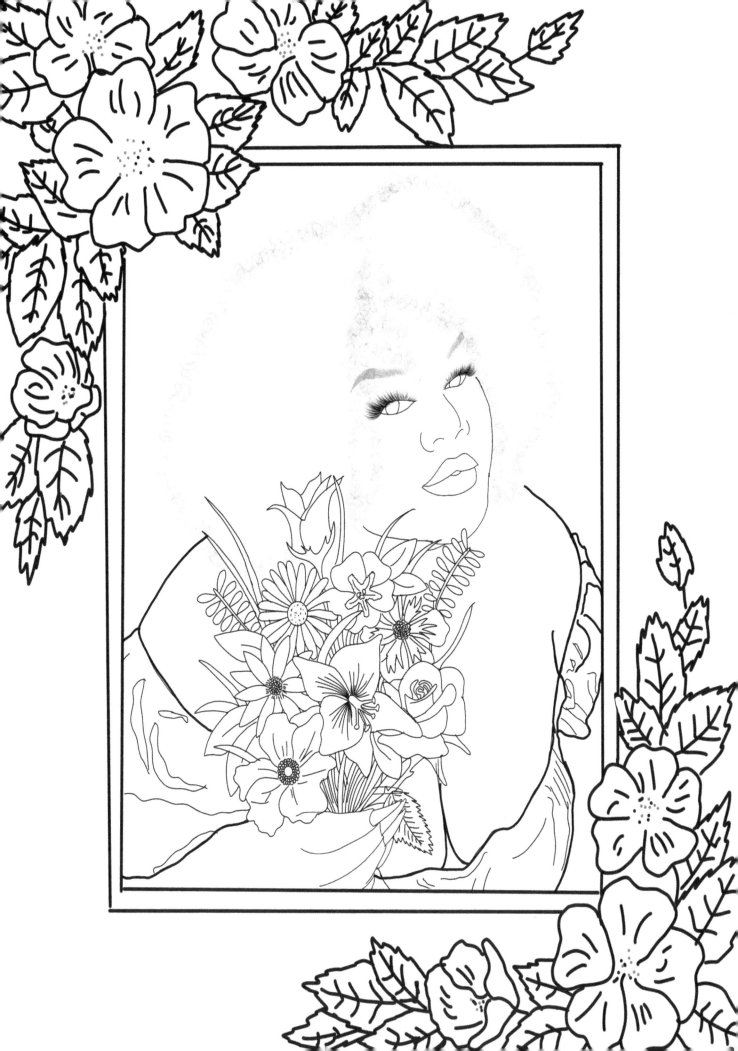

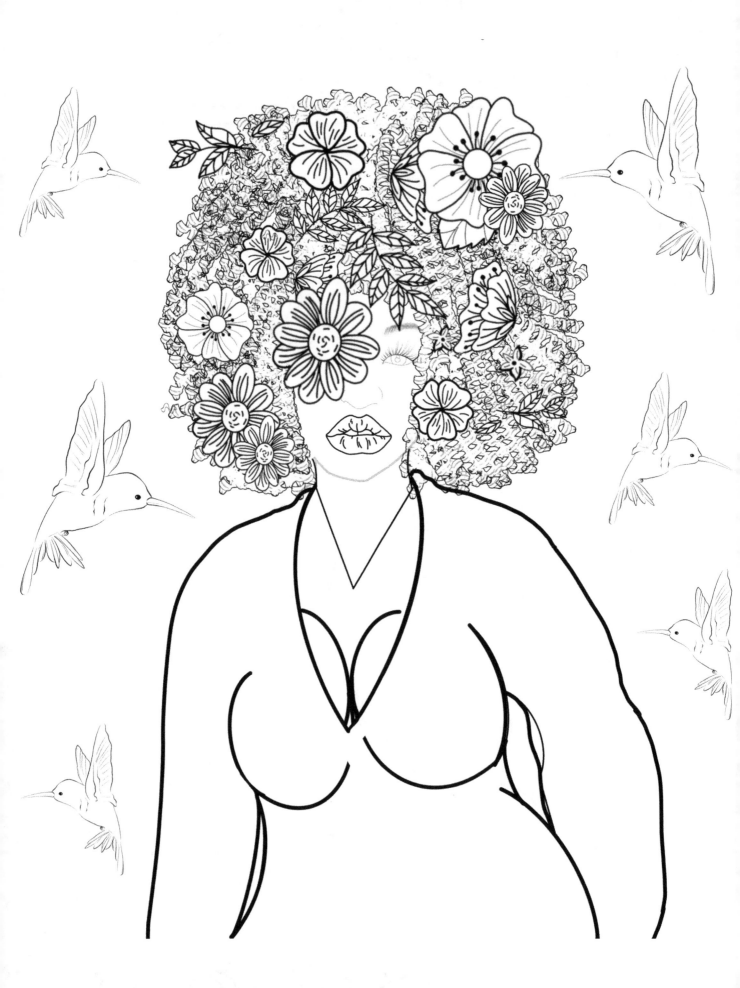

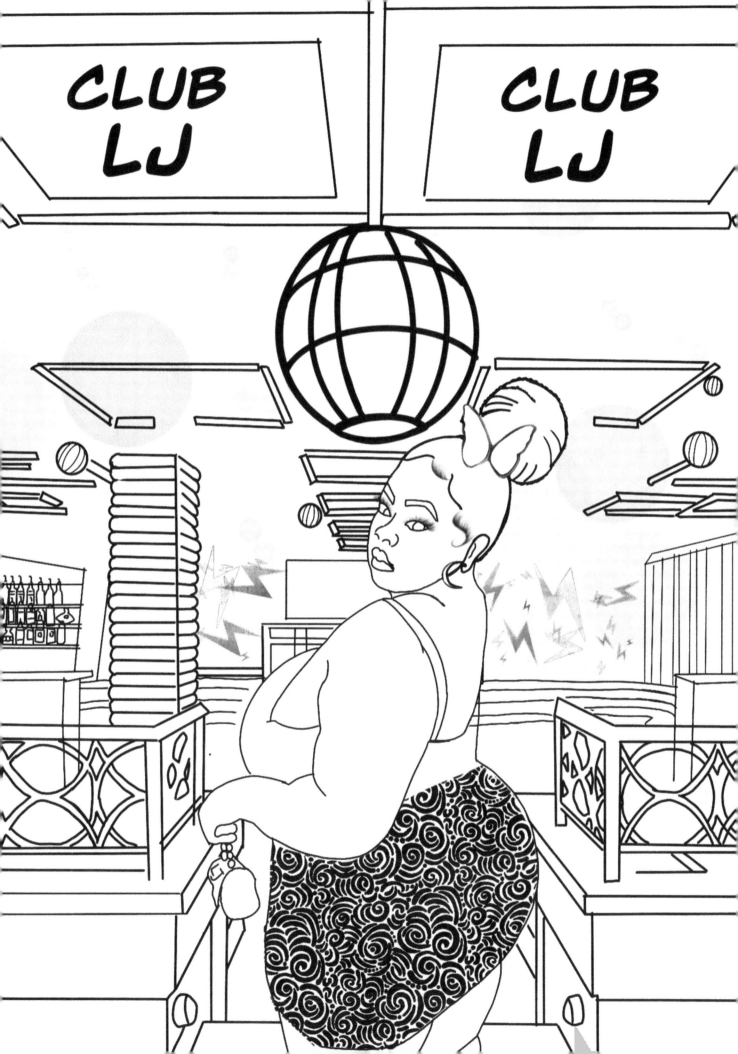

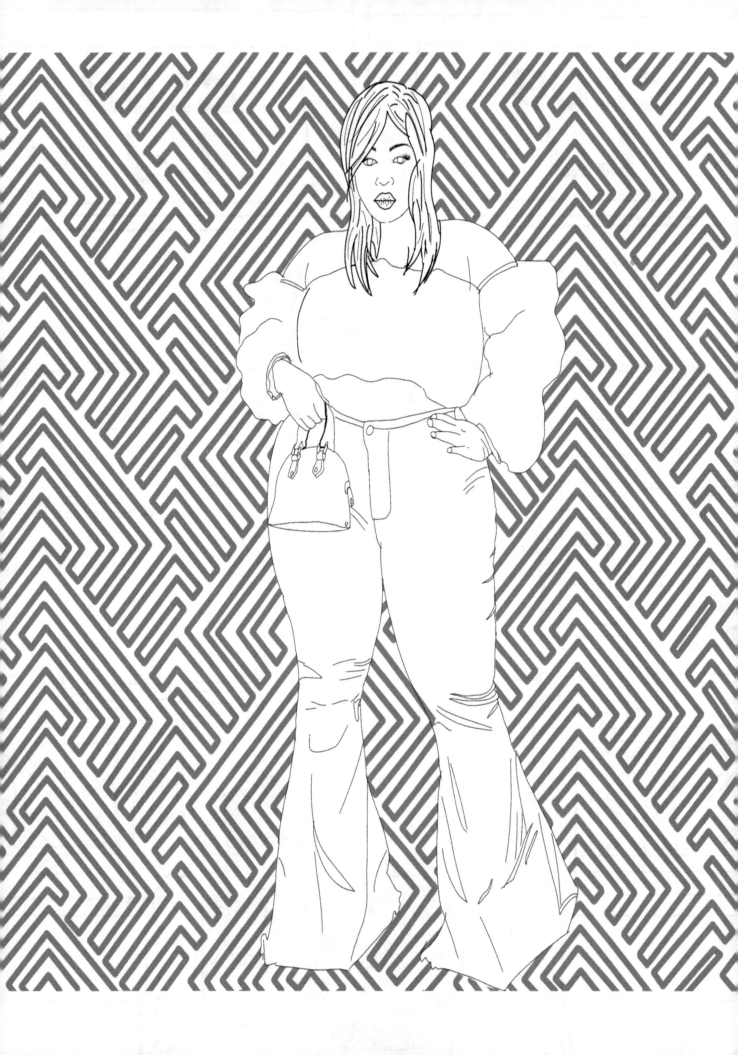

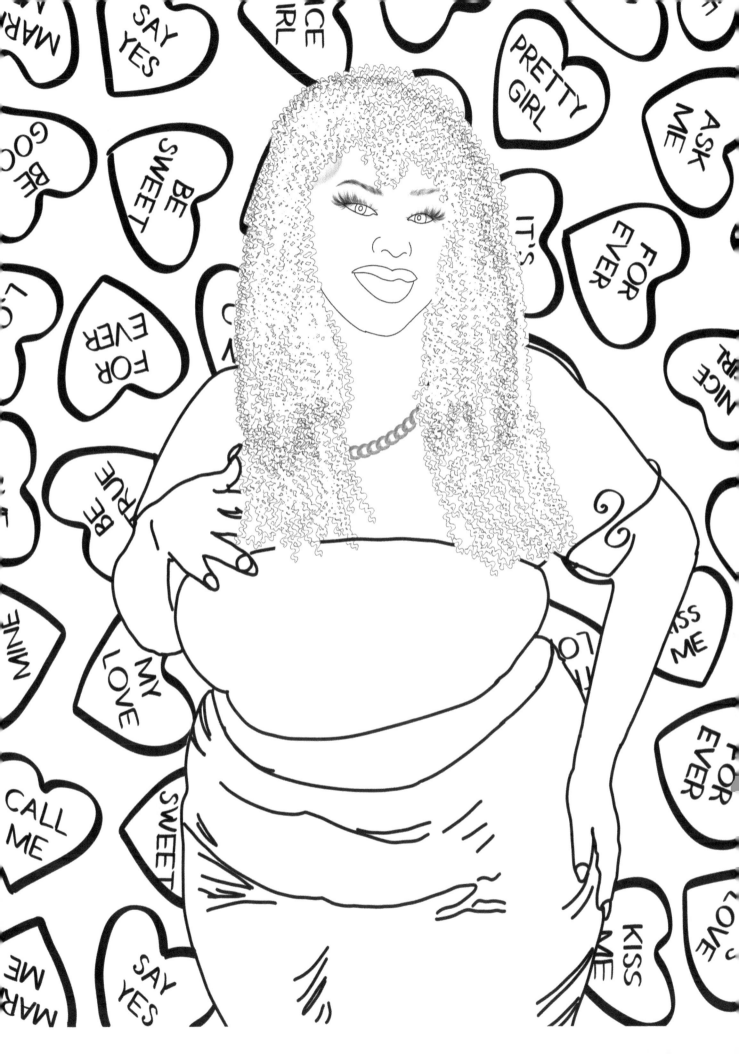

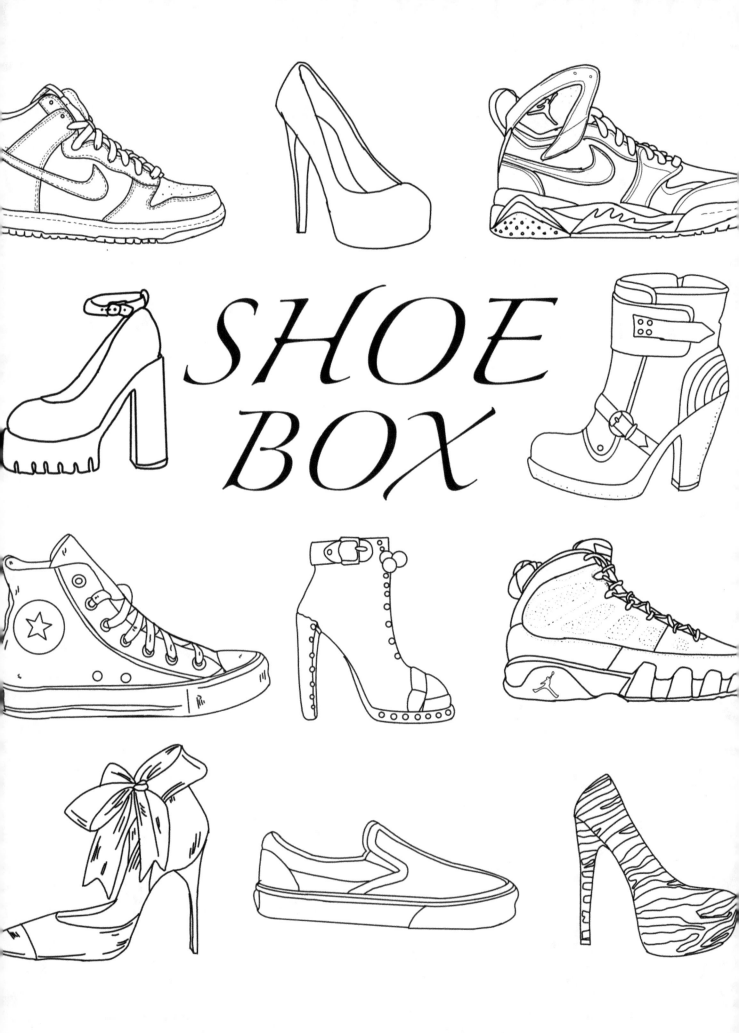

SHOE
BOX

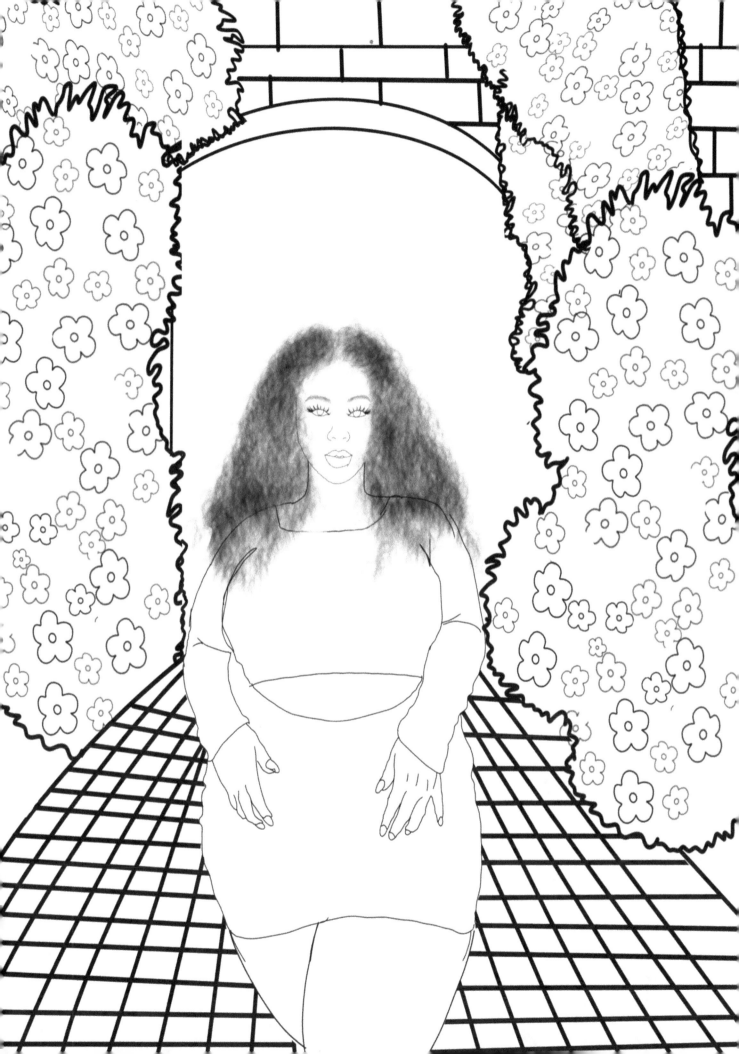

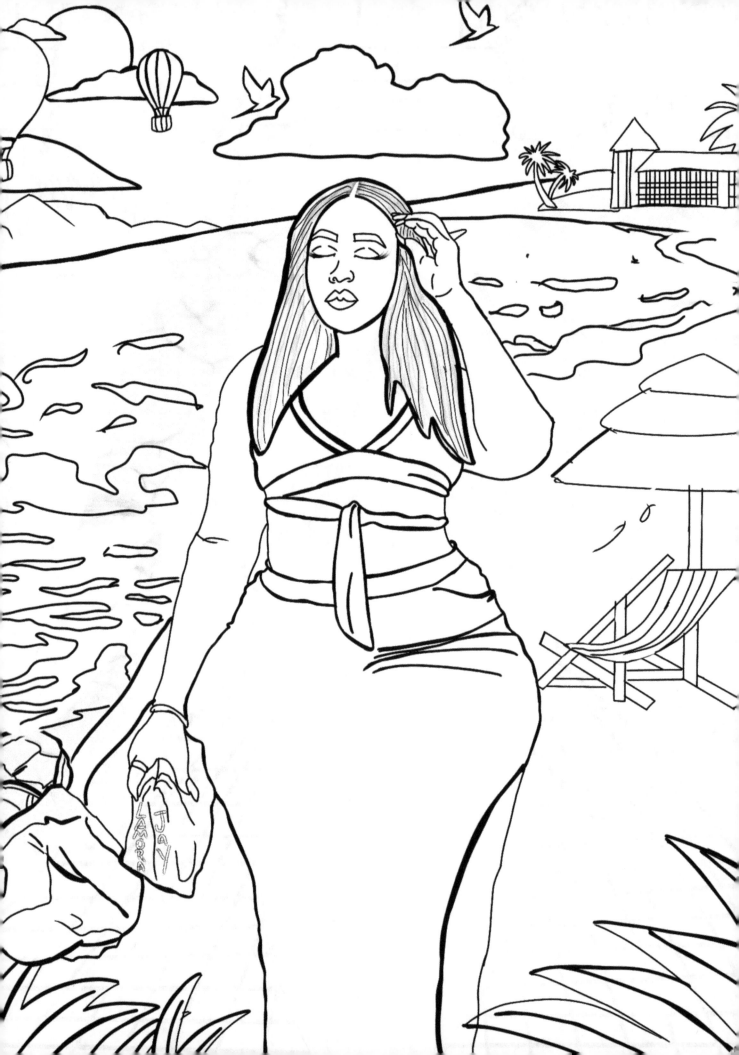

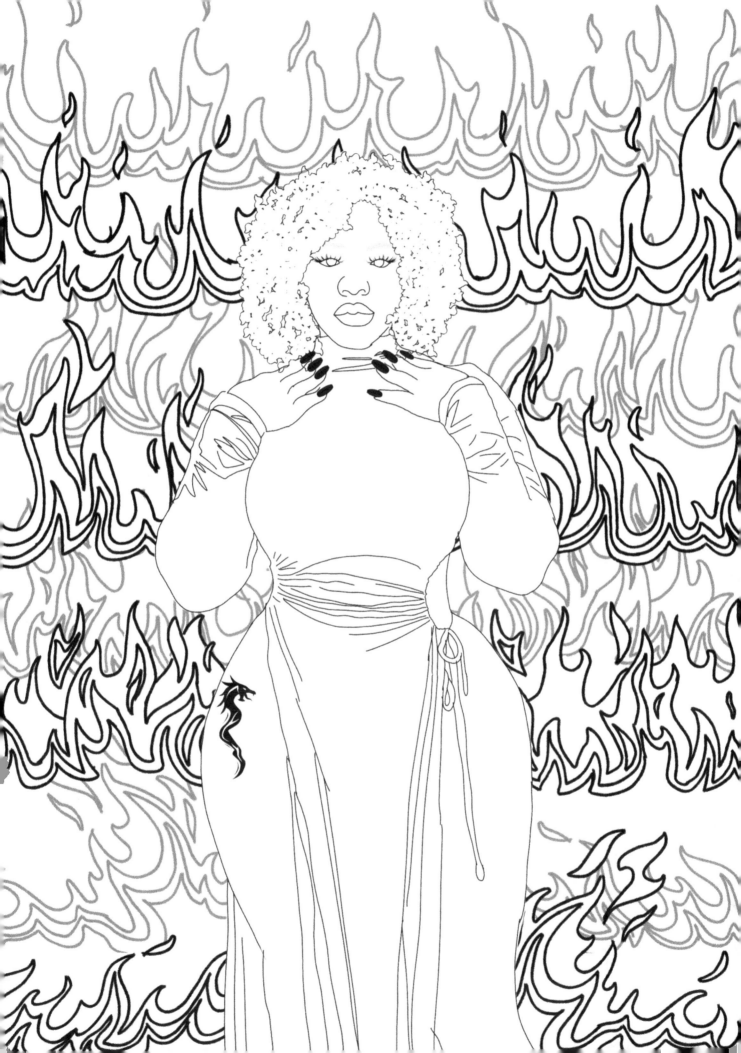

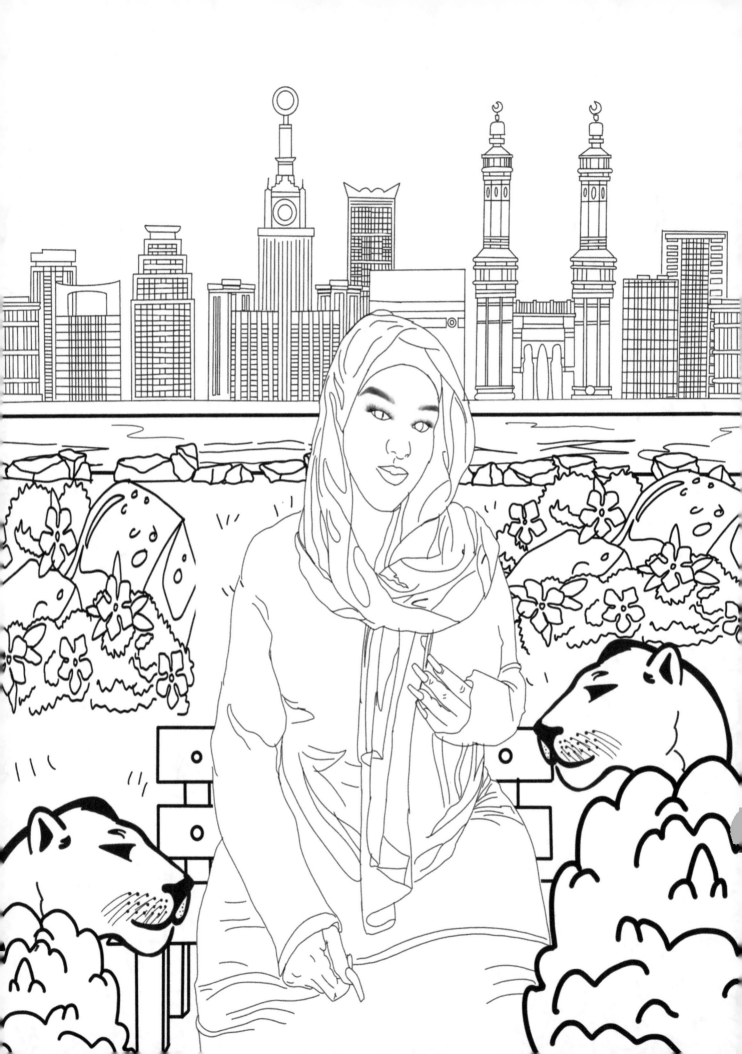

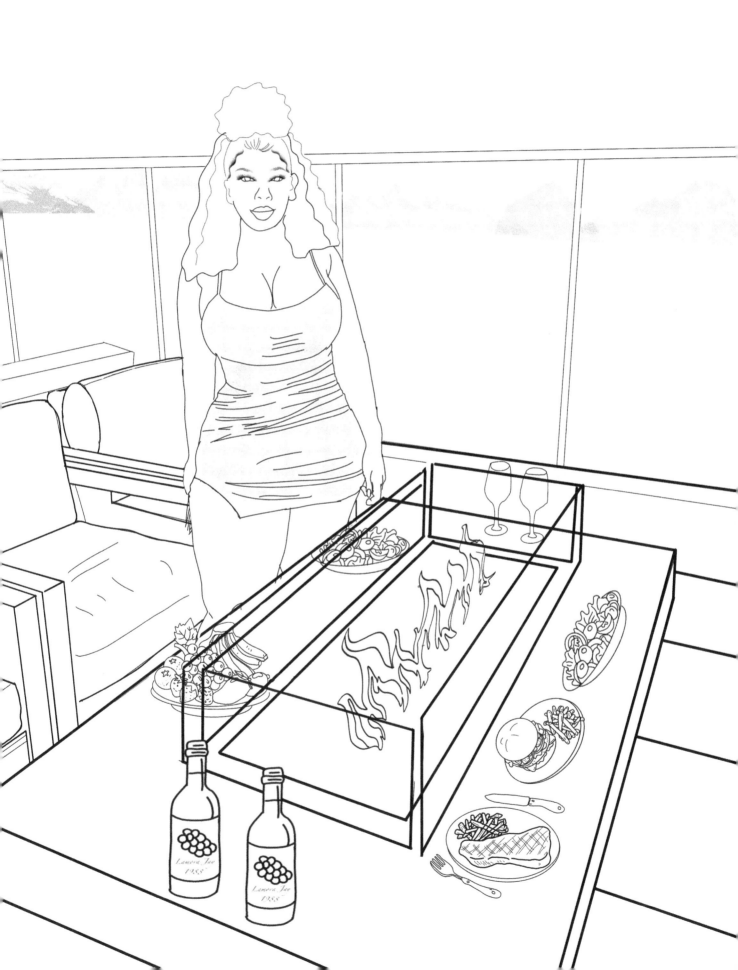

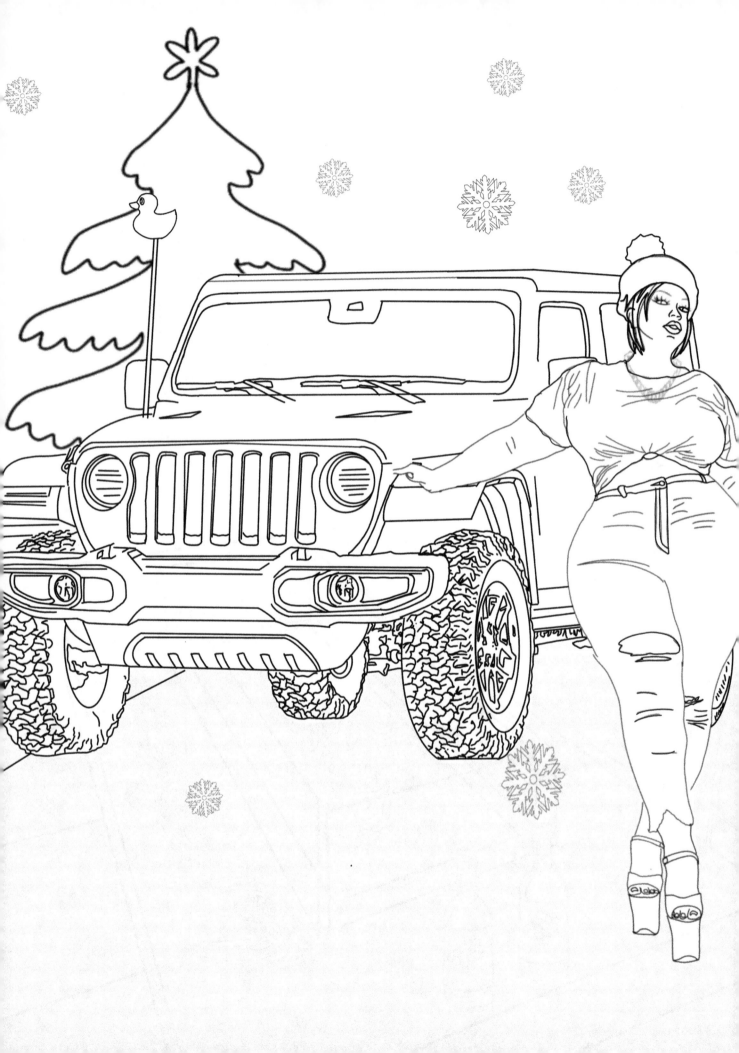

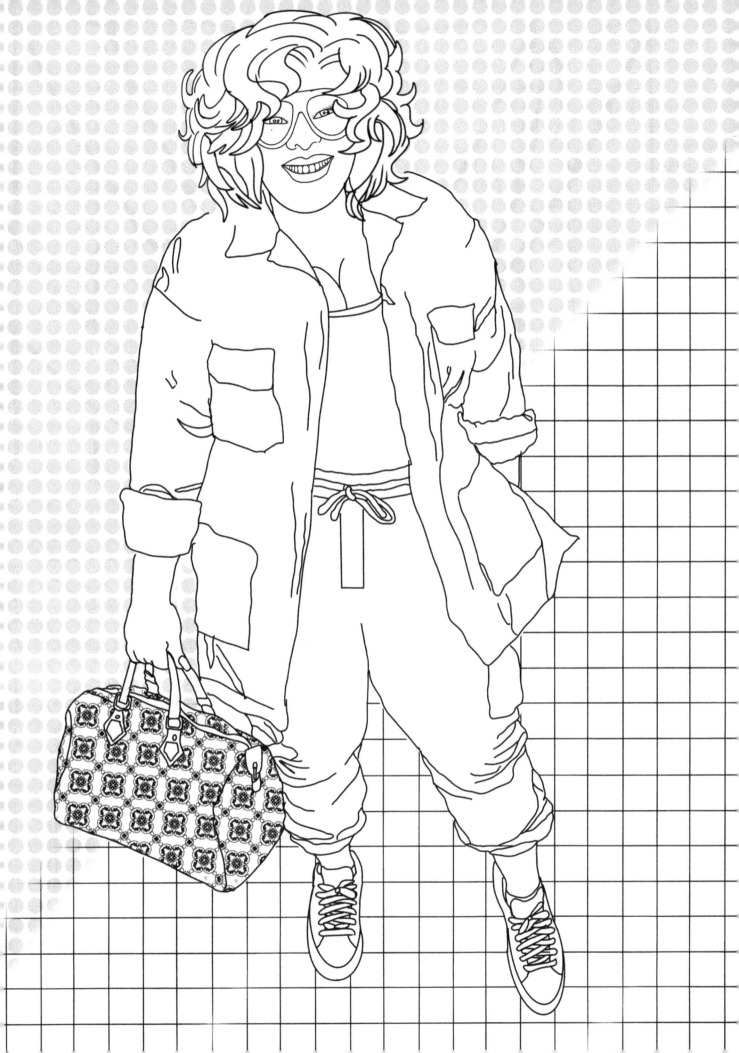

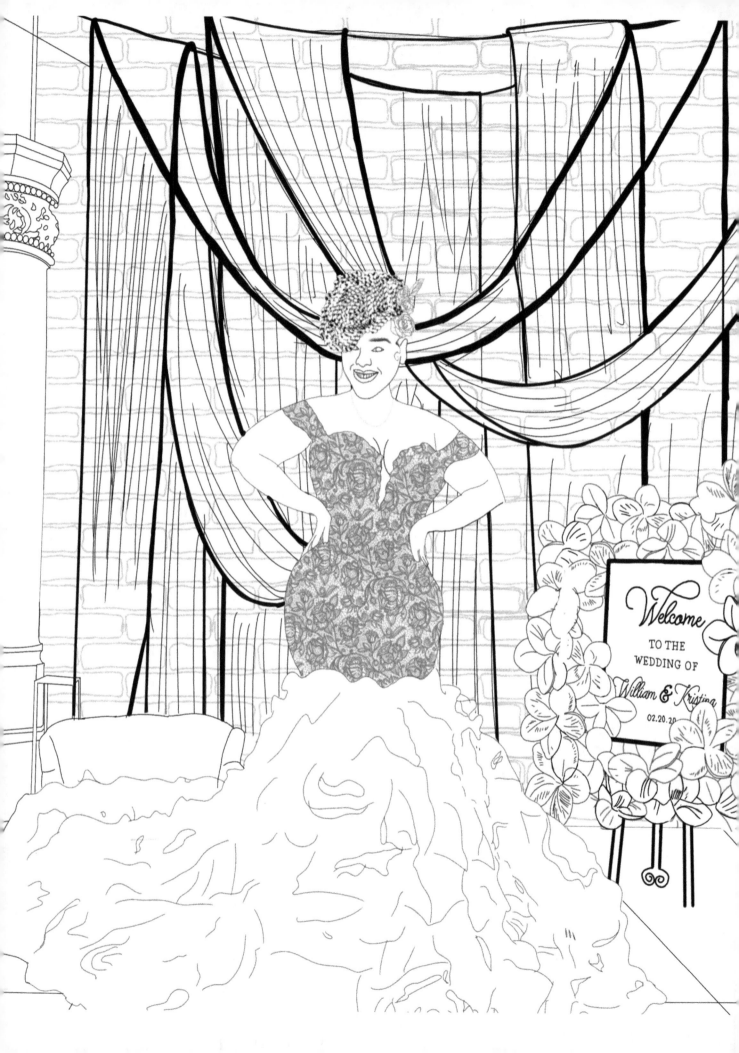

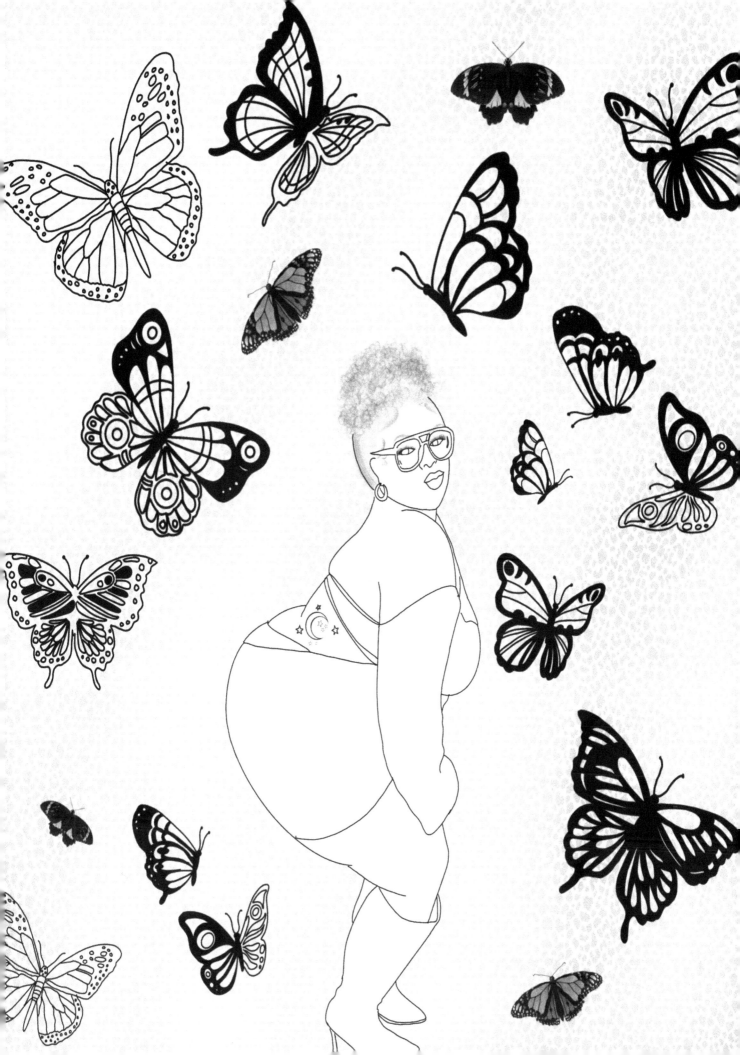

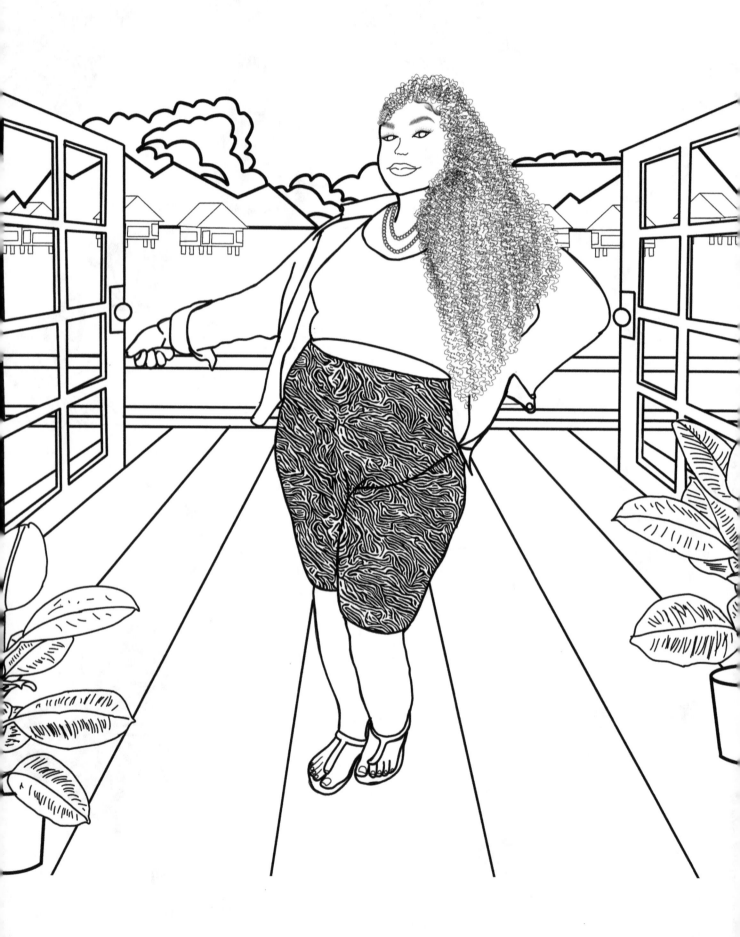

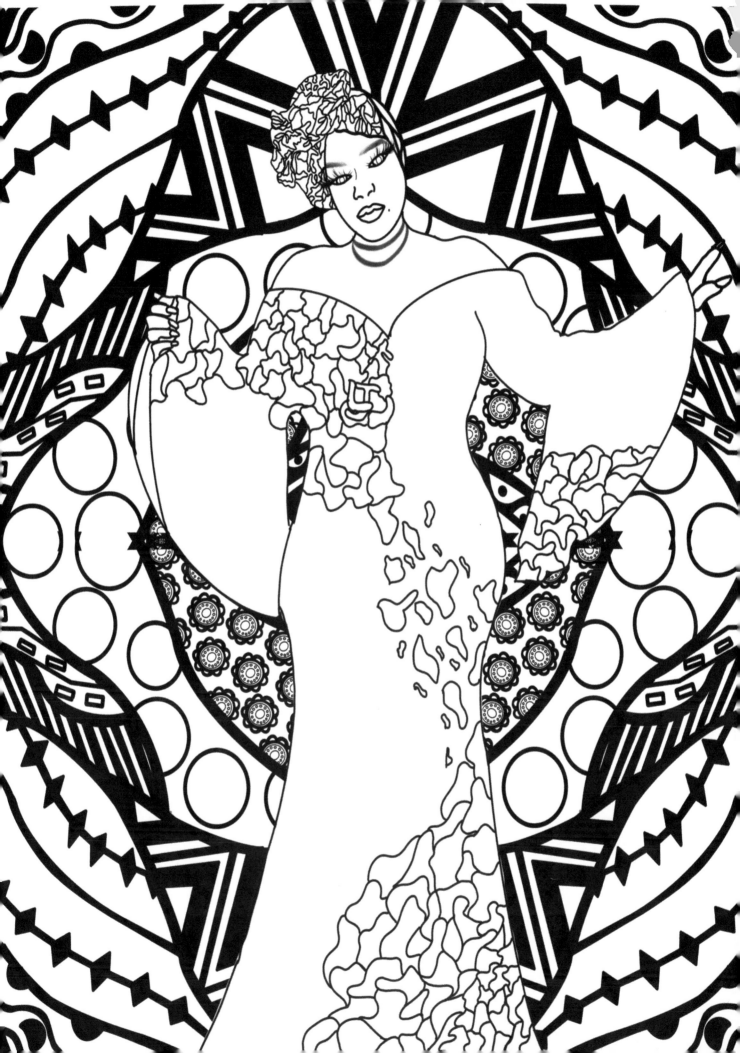

Printed in the USA
CPSIA information can be obtained
at www.ICGtesting.com
LVHW061506230823
755929LV00012B/336